for Les

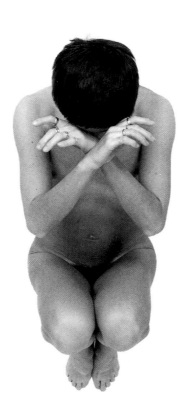

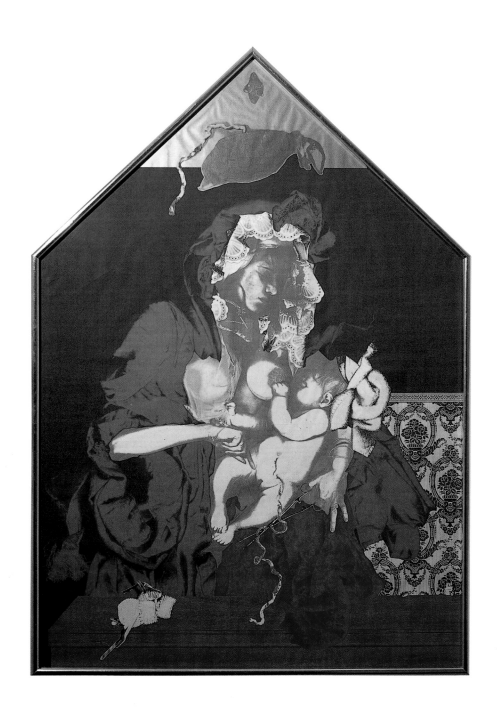

One Flesh

Photocopies 160 × 107 cm

ENFLESHINGS

Helen Chadwick

with an essay by Marina Warner

PMA Withdrawn

APERTURE/A NEW IMAGES BOOK

M
CHADW-H
E56
Q
PR(NH)

CONTENTS

EGO GEOMETRIA SUM

Suppose one's body could be traced back through a succession of geometric solids, as rare and pure as crystalline structures, taking form from the pressure of recalled external forces . . . the incubator, laundry-box, font, pram, boat, shoe, wigwam, bed, piano, desk, horse, temple, high school, door . . . and if geometry is an expression of eternal and exact truths, inherent in the natural law of matter and thus manifestations of an absolute beauty, predestined, of divine origin . . . then let this model of mathematical harmony be infused with a poetry of feeling and memory to sublimate the discord of past passion and desire in a recomposed neutrality of being.

. . . As if it were possible to resolve the pull of the past, the friction in remembering, and so discover an
inherent pattern to existence. A metaphysical conceit, to be 'happy in having understood the causes of
things',[1] has forged this detachment. As autobiographical subject, I am proposing an order, a narrative of
material objects, equivalents for selfhood, within a bounded safe place. The minutiae of personal history
are collapsed into an idealised universe, a system of solitary finite masses inside the classical frame of a
Newtonian world-view.

1.
Virgil, The Georgics II 490

Thirty years are reduced to ten geometric solids, exactly determined by what took place at a particular
point in time. These 'accidents of matter' constitute the past, the collisions between my body as a growing
child and a succession of everyday cultural objects. Essentially they are that body, being equal in volume
but recomposed under strict causal laws, flesh into form. Their surfaces, simultaneously image and
material, are impregnated with the photographic impression of each physical encounter. These fugitive
traces offer evidence of the passage of time, the effects and constraining influence of socialisation. Initially
compressed into sympathetic volumes, the vulnerable child undergoes the complete development of these ideal
forms from the early curvilinears to the progressive angularities of growing up. The abstract geometry
embodies the principles of permanence – the tough fabric of matter being somehow more substantial than
lived experience and more emphatic than simulacra.

Nostalgia for a coherent unity, a wholeness, is culpable for this closed world. However, what
of that which is left out, absented from the symbolic order? The distinction between occupied and empty
space is clear. It marks the boundaries of the body, the limits of the constructed self. But within the
gentler, less than absolute enclosure of the drapes are tacit echoes of a pleasurable impulse. Beyond the
inertia of these material bodies and the certainties of their rational mechanics resonate the warm inaudible
rounds of memory, subjective chords of Mnemosyne, posing the potential for new formulations.

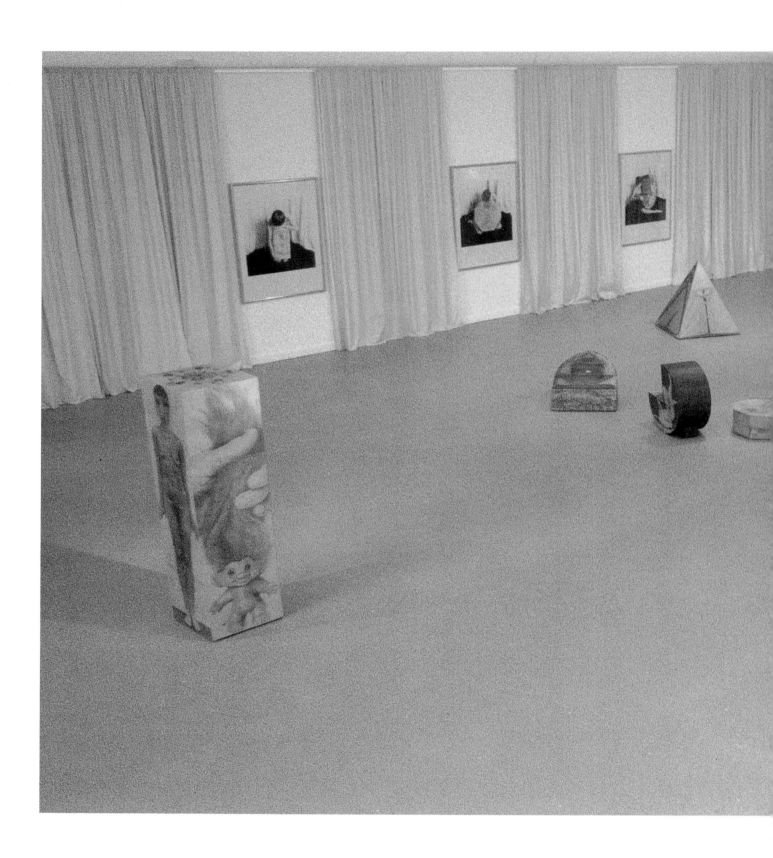

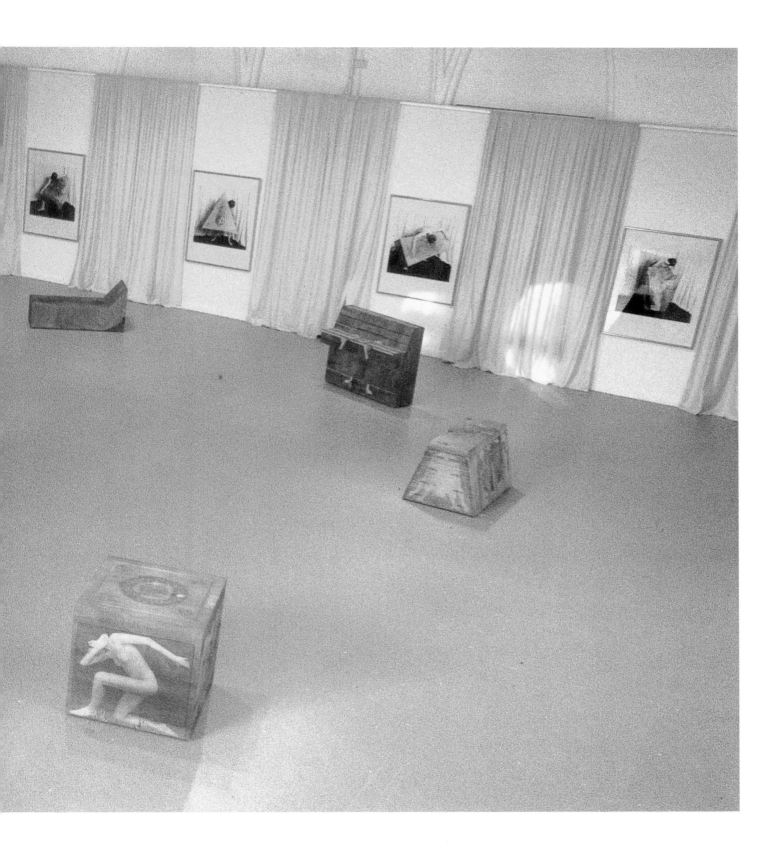

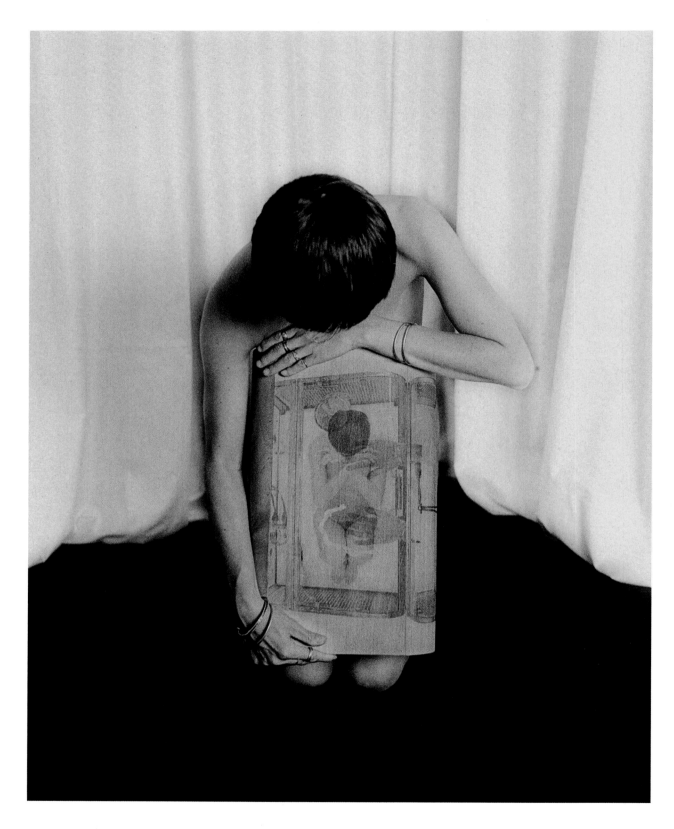

The Labours I

Dyed silver gelatin photograph

122 × 91 cm

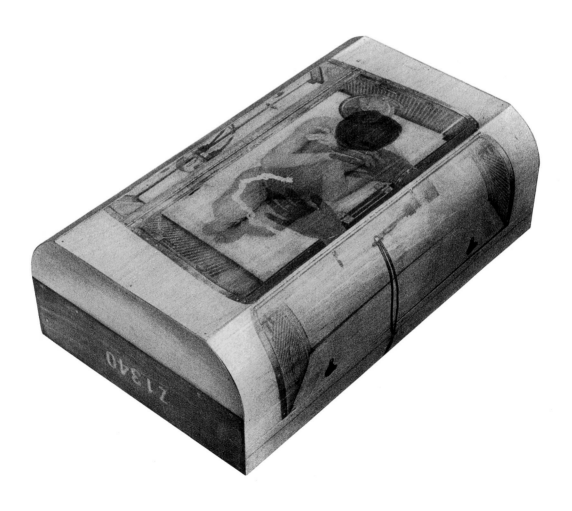

Incubator – birth

Photographic emulsion on plywood

15 × 27 × 45 cm

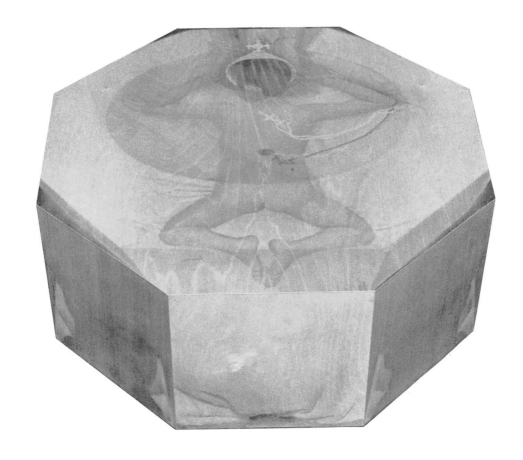

Font – 3 months

Photographic emulsion on plywood

23 × 50 × 50 cm

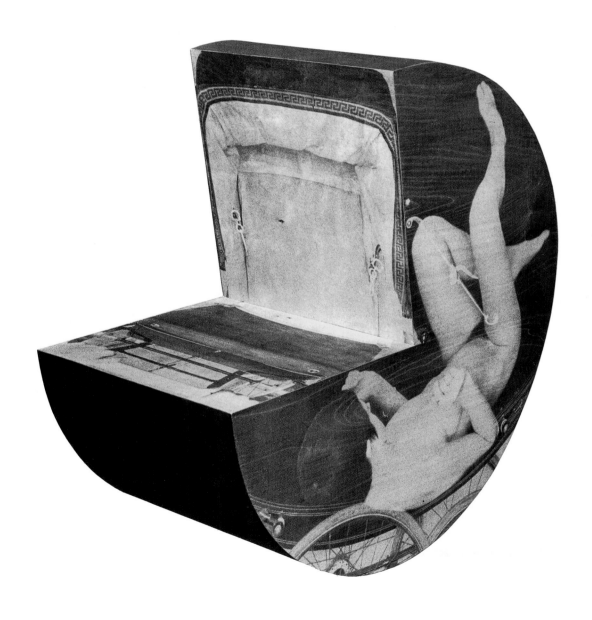

Pram – 10 months

Photographic emulsion on plywood

64 × 32 × 64 cm

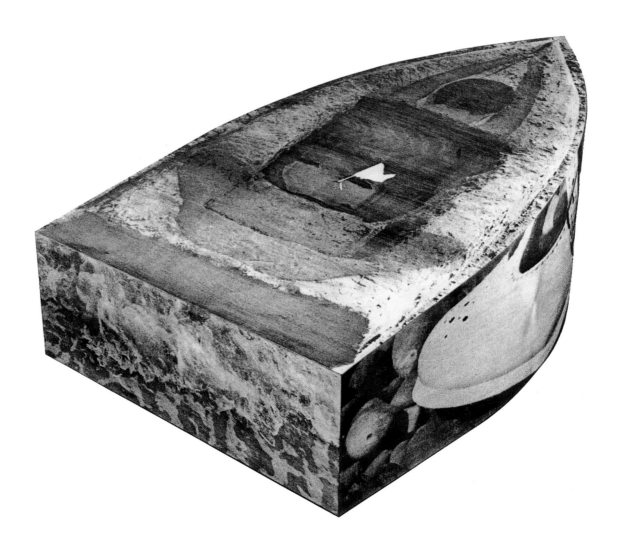

Boat – 2 years

Photographic emulsion on plywood

38 × 24 × 91 cm

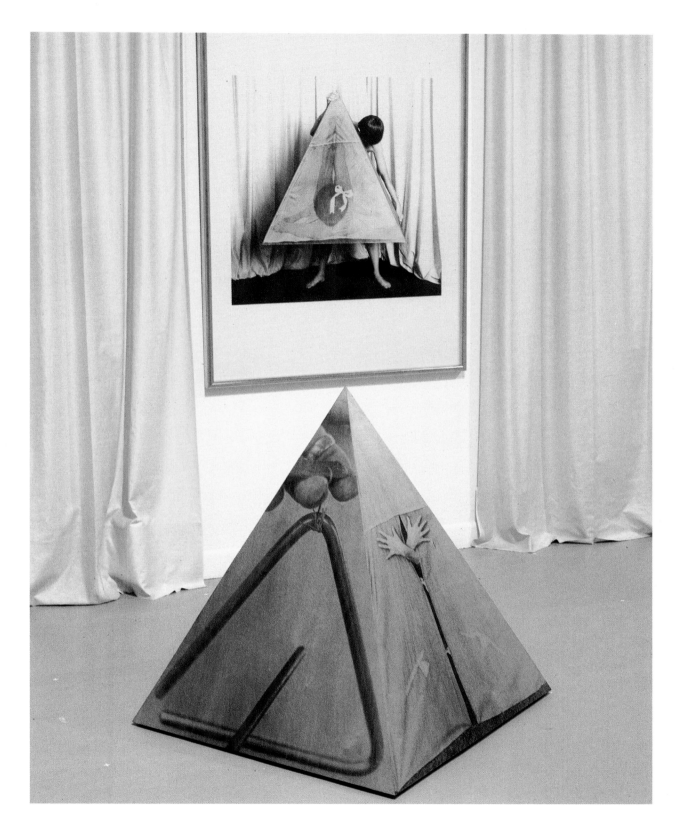

Wigwam – 5 years

Photographic emulsion on plywood

89 × 79 × 79 cm

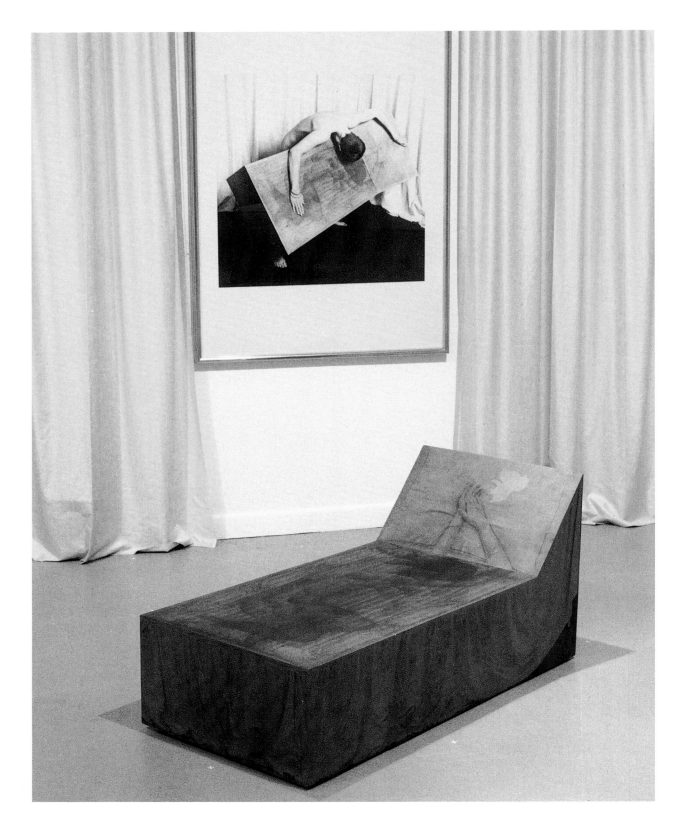

Bed – 6¾ years

Photographic emulsion on plywood

54 × 56 × 115 cm

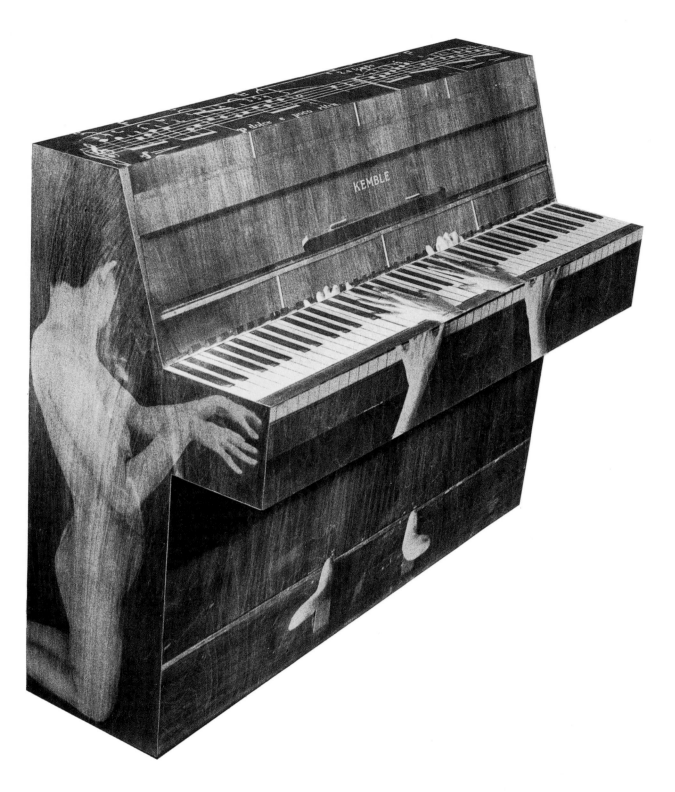

Piano – 9 years

Photographic emulsion on plywood

86 × 42 × 105 cm

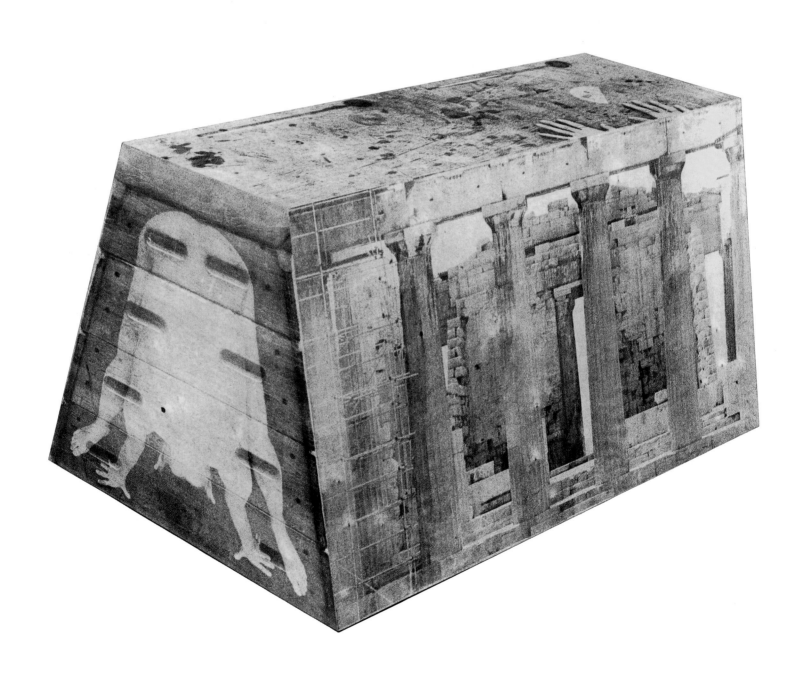

Horse – 11 years

Photographic emulsion on plywood

56 × 62 × 102 cm

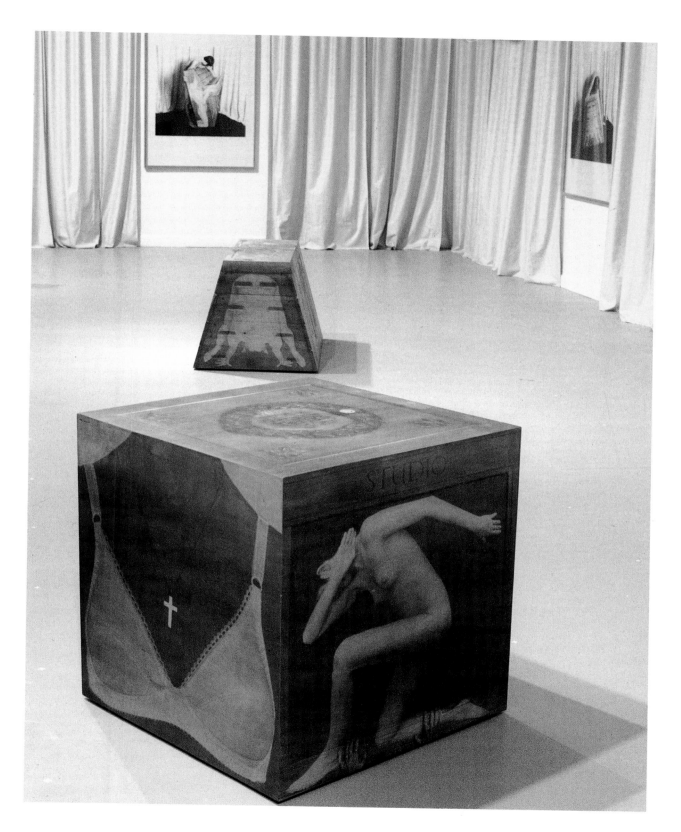

High School – 13 years

Photographic emulsion on plywood

70 × 70 × 70 cm

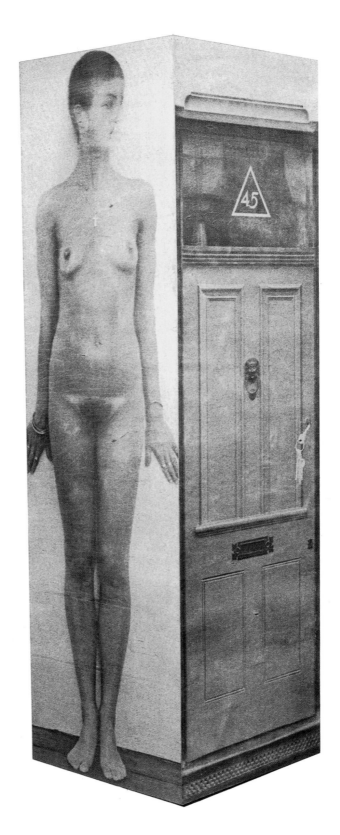

Statue – 15 to 30 years

Photographic emulsion on plywood

160 × 46 × 46 cm

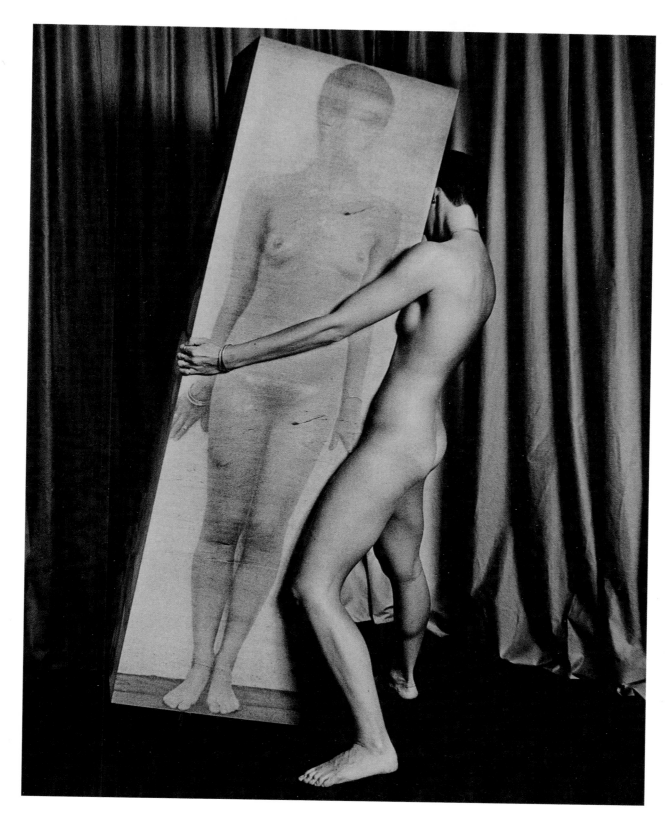

The Labours X

Dyed silver gelatin photograph

122 × 91 cm

OF MUTABILITY

Before I was bounded, now I've begun to leak . . .

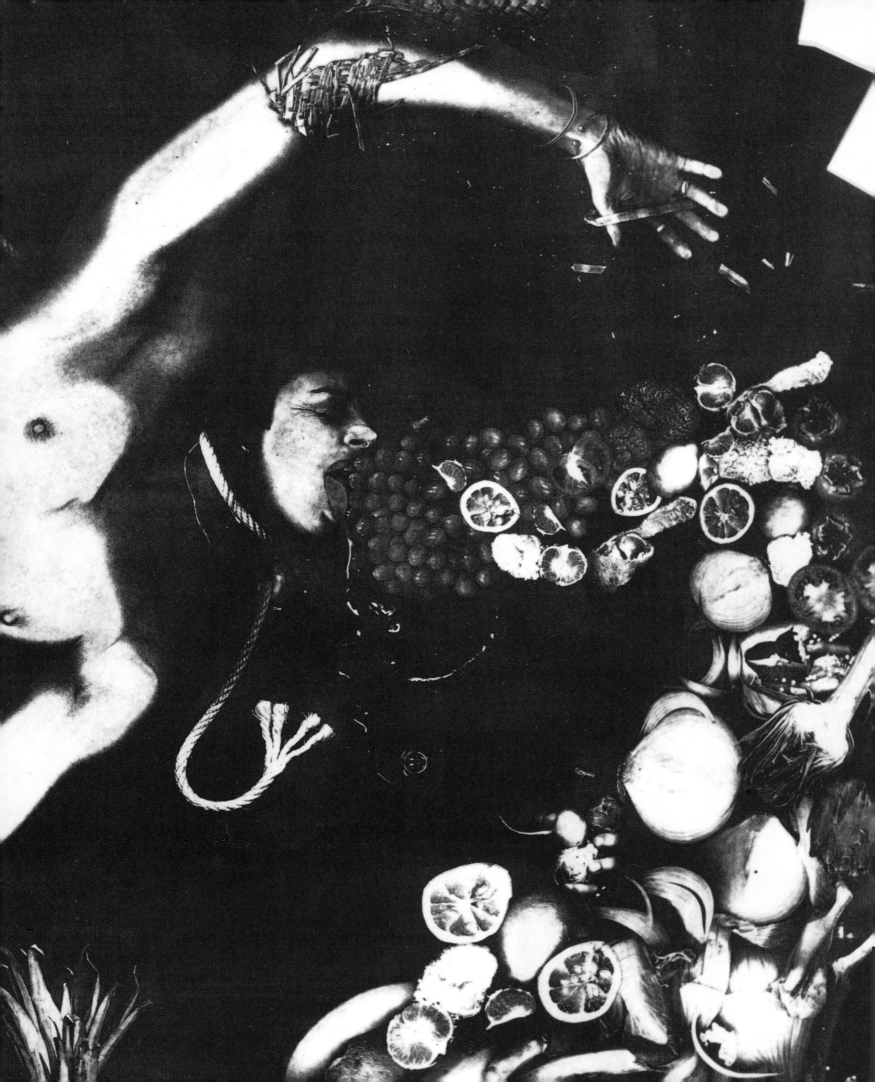

The solitary repressive ego, harnessed to language, is sovereign. Sense has subjugated sensation. What if dangerous fluids were to spill out, displacing logic, refuting a coherent narrative, into a landscape on the brink of I. Beyond description, beyond the symbolic, in the realm of direct sensory experience, excess is expression.

I have exchanged the moralities of the vanitas, homo bulla *– man, a bubble, for a world blown from the impassive bubble chamber of a photocopier. Light, in the flicker of an instant, unflinchingly records whatever lies on the glass plate. Physicality is reduced to surface, a mere echo of itself, the corporeal imploded into grains of dust. Dismembered into manifold fragments, the subject shatters, and under the callous intimacy of the reprographic passes into transience. This leaves only the senses, themselves of no substance, free to recognise these traces and act as author. Despite the seams discretely betraying a feigned continuity, all may be reassembled to give measure to unformed, imaginary relations. The appearances are saved; the particles recast into diagrammatic fields radiating outwards from a notional centre. Both less yet potentially more than its original, the real is resurrected and set adrift.*

Out of the copier, no longer separate from other things, I am now limitless. The essential elementary self is gone, evaporated into a vigorous plurality of interactions. I discharge myself, time and again, in a discontinuous flow, a passage of impossible states leaping into successive configurations. These are dynamic allegories for events to be; a spectrum of desires and impulses, willed, personalised then freely rescinded to corrupt into fresh fictions. Within each event the position of things is given, but the emotive momentum is left hanging. It may be perceived literally as an outwardly manifest reality, a mirror, or experienced by the eye alone, but will only become palpably real if felt deep within the reflexive domain of introspection. Open to speculation yet unfathomable, as oracle I draw the breath of stimulus itself. The temporal field has dispersed into sensory shallows. I am merely a tendency to exist, scrolls of pure conjecture enunciating inwardness.

Pleasure and pain are simultaneous in the illusory frame of this place, free from the dimension of shame and guilt. Neither solace nor promise, as Eden at the beginning and Jerusalem at the end, mark the polarities of time, for there can be no arrival here. The boundaries have dissolved, between self and other, the living and the corpse. This is the threshold of representation, not quite real, not exactly alive, but the conscious implicate depths of reflection.

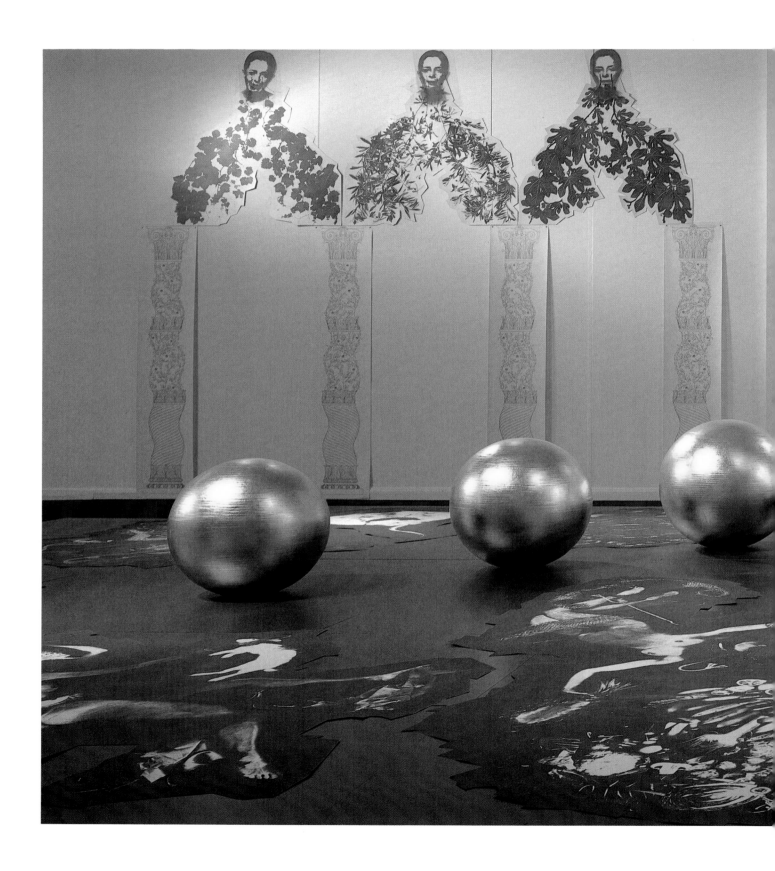

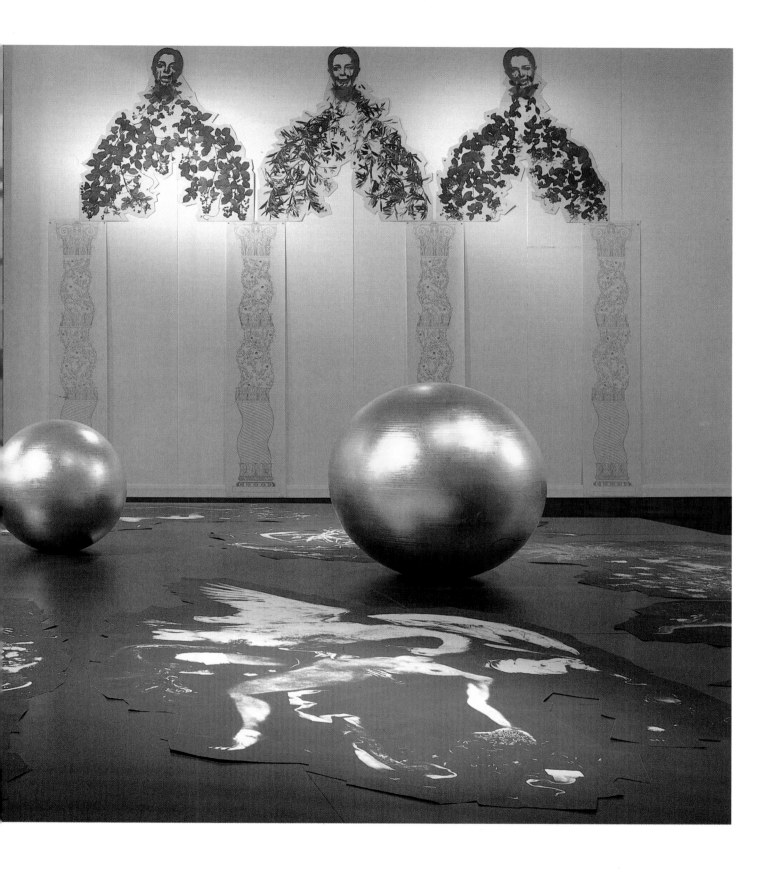

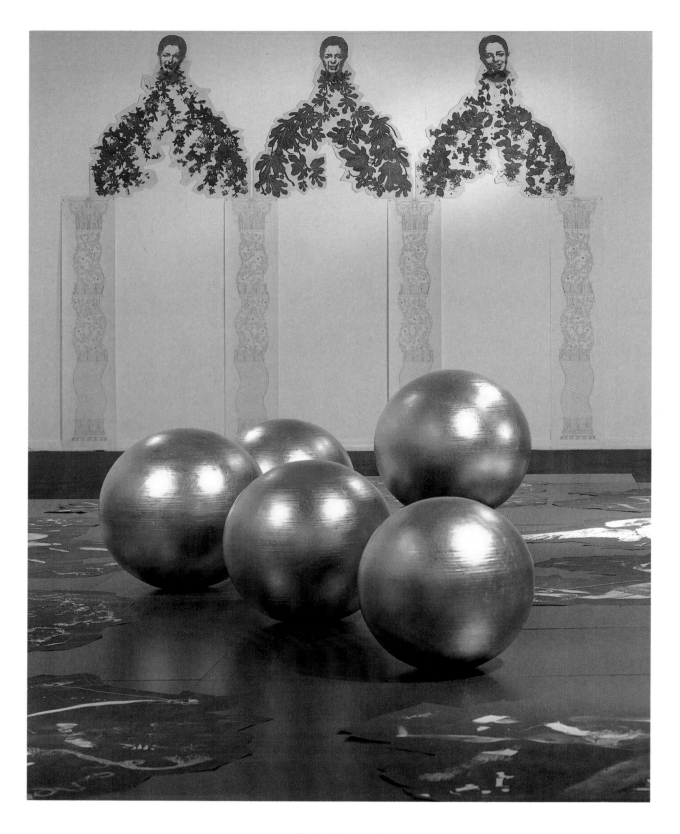

The Oval Court (detail)

Photocopies and assorted media

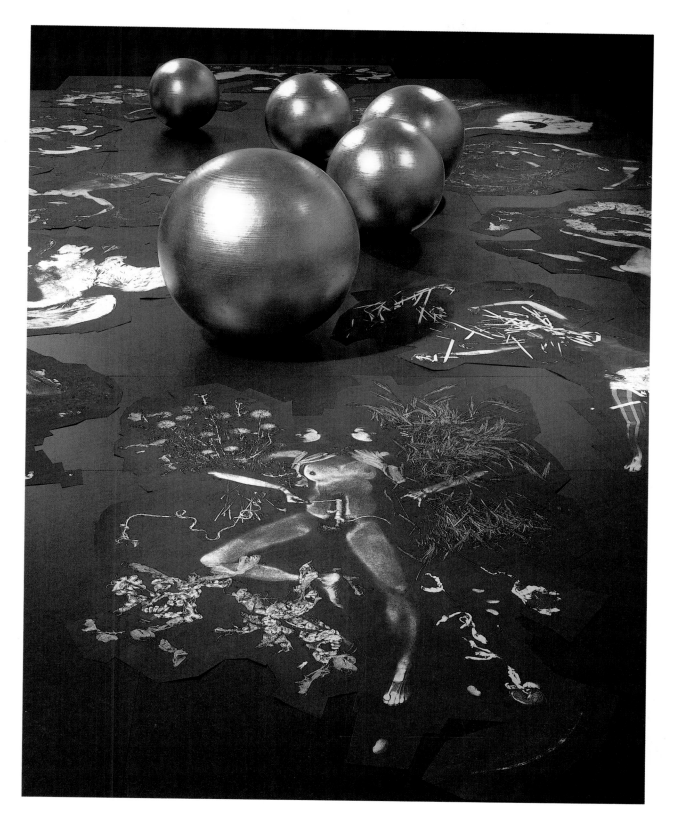

The Oval Court (detail)

Photocopies and assorted media

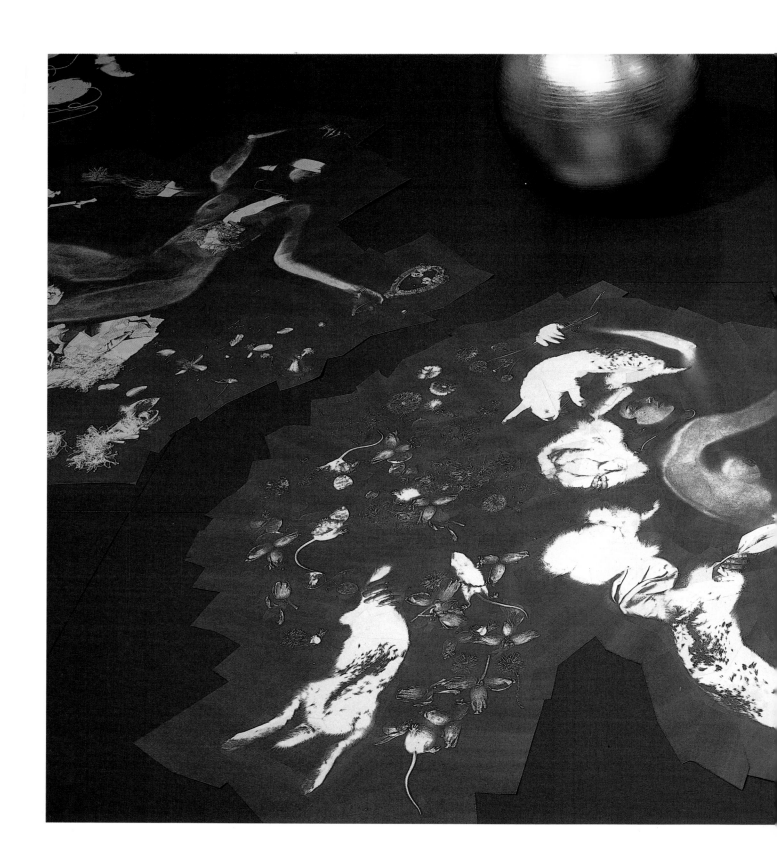

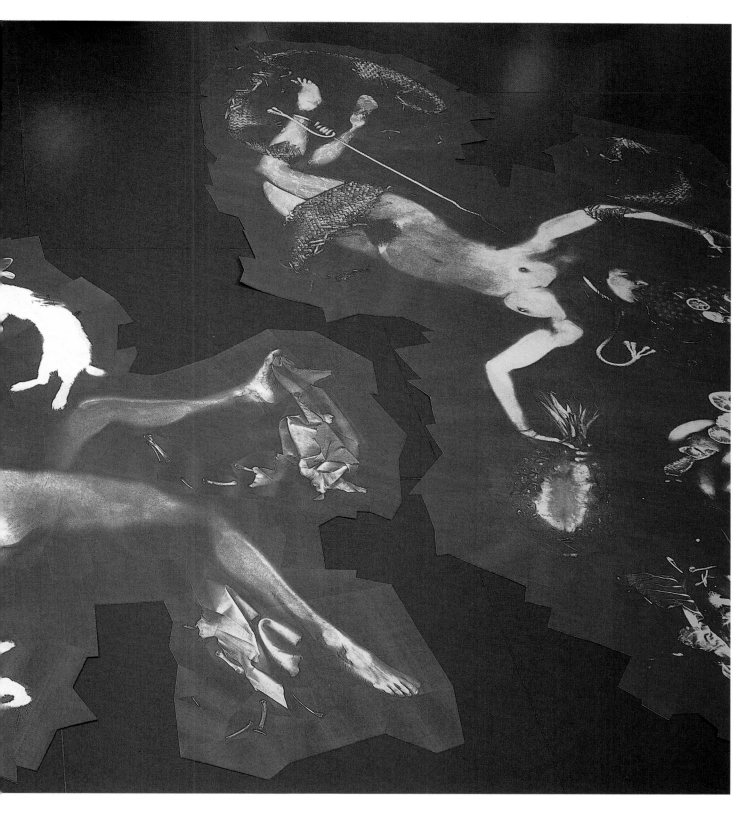

The Oval Court (detail)

150L M/A–11 (135gsm S/P) (M

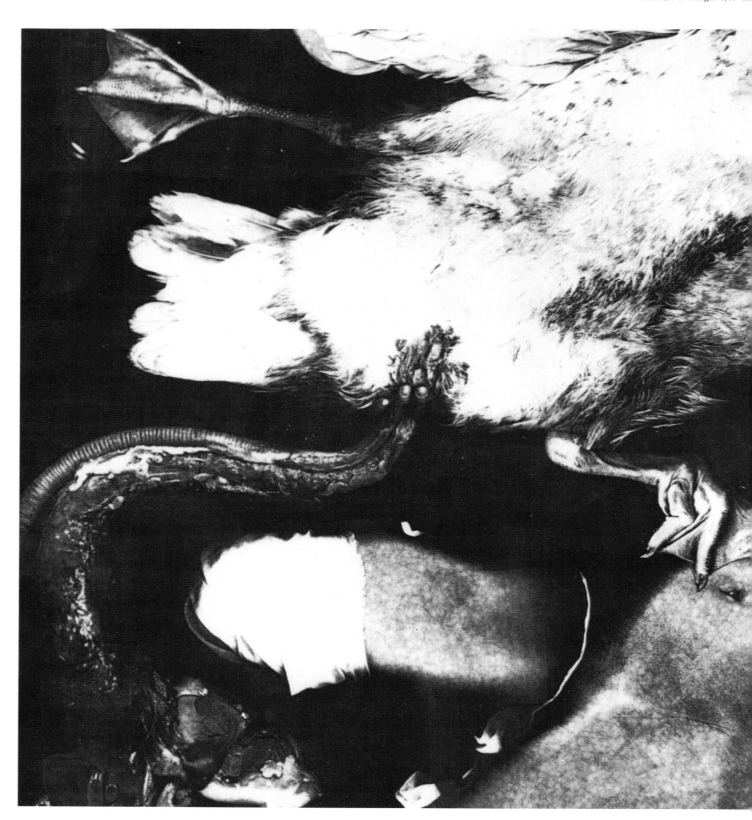

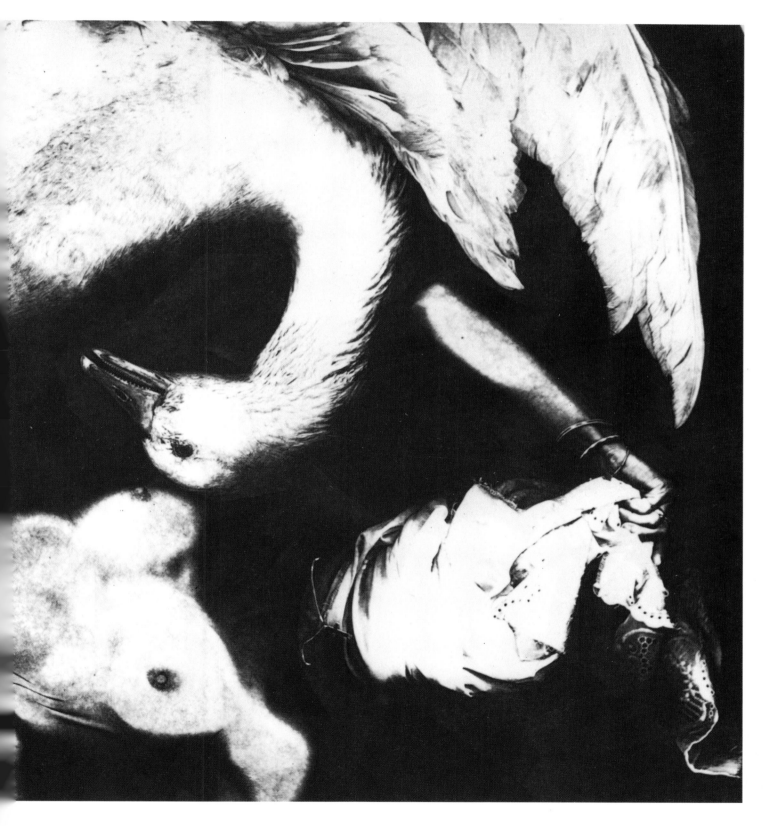

The Oval Court (detail)

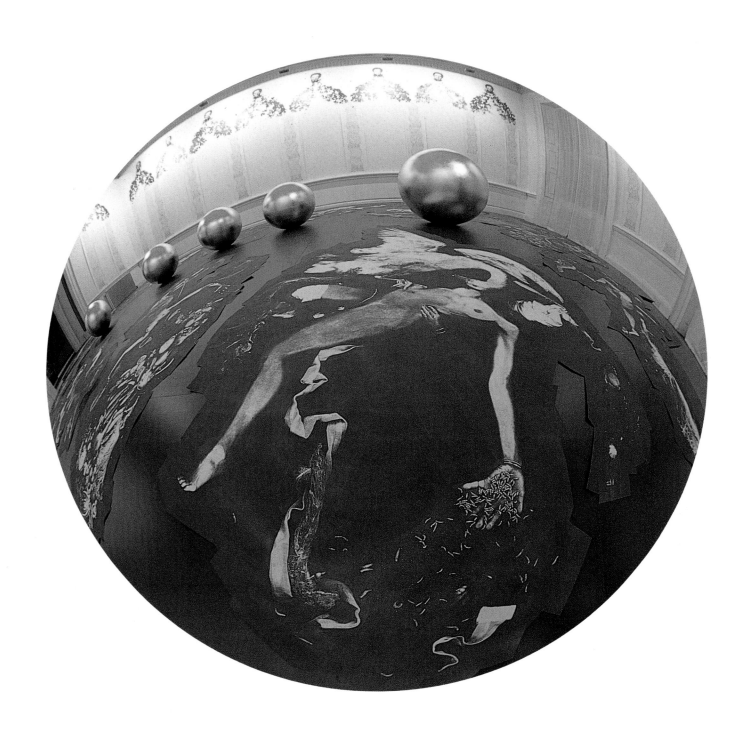

The Oval Court

photocopies and assorted media

Installation ICA, London

In the Garden of Delights

MARINA WARNER

IN THE GARDEN OF EDEN, Eve wasn't alone. The most familiar story of Creation tells us the first man named all created things, and then that God saw Adam was lonely and made a companion for him from his flesh. Adam then named her too, 'Eve', mother of all the living. She left that symbolic place at his side when the serpent tempted her, but took it again when she handed him the apple of knowledge. Though the first woman, she was never single; even in widowhood her children surround her, as in Piero's profound meditation on the death of the first man in Arezzo. Eve's declared contingency ('Thy desire shall be to thy lord') follows on her breaking the greater Lord's prohibition, against eating the fruit of the tree of knowledge, but it coheres with her speechlessness in her moment of origin and her absence from the act of naming. Much contemporary enterprise by women wants to undo that particular curse.

In Helen Chadwick's 'Of Mutability' we enter into a post-lapsarian Paradise where woman is visible alone among humankind, where she is the matter in question, but what matters is her passion, her physical articulation of her feelings, her relation to created things and her choice among them; where her aloneness is not an issue and absence not felt, as was the lack of woman felt by Adam. We are introduced into a cycle of experiences, mediated through an imaginary body composed from the artist's own, from photocopies in collage.

> *'I want to catch the physical sensations passing across the body – sensations of gasping, yearning, breathing, fullness,'* says the artist. *'The bodies are bearing their sexuality like a kind of Aeolian harp, through which the sensations are drifting and playing. Each of them is completely swollen up with pleasure at the moment when it's about to turn, each has reached the pitch of plenitude before it starts to decay, to empty . . .'*

The twelve figures, each at a different station on the way of pleasure, at the twelve gates of Paradise, float in a raised pool. Reminiscent of a cistern in a Moorish garden, like the Alhambra's, it is fed by the tears wept by the heads at the top of the Salomonic columns arranged around the pool. The columns twist like the skein of intermingled pleasures; no Doric sternness gives them weight or tectonic force. The face of the weeper – the artist's own – has open eyes, though screwed up by tears; the eyes of the figures in the pool are closed. Her tears roll down for remembered bliss, for erotic fantasies, and dreams of pleasure that of their essence are transitory; then evaporate into the air, up towards the weepers and so, in 'Of Mutability',

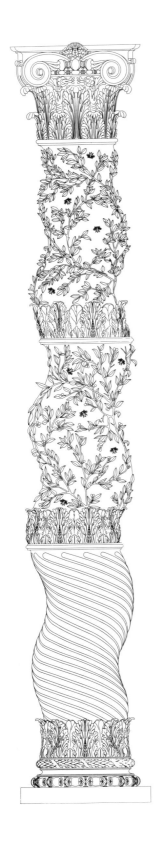

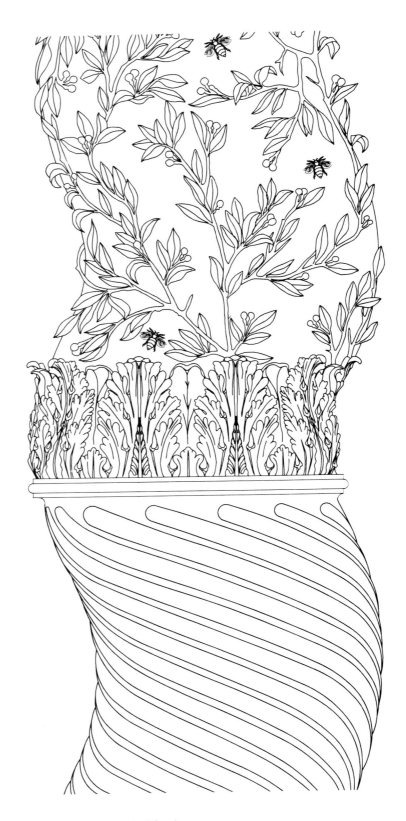

Salomonic Column (detail from the Oval Court)

201 × 40.9 cm

GDS computer plot with Philip Stanley

'Love materialises as a cyclical flow of water.'

Helen Chadwick is capturing the fugitive not in a spirit of grief or censure, but in celebration:

'I want to make autobiographies of sensation, to find a resolution between transience and transcendence.'

In 'The Oval Court', each of the figures floats in an embrace around the perimeter of the pool on which are poised five golden spheres: with the encircling colonnade, these form the major architectural motifs in

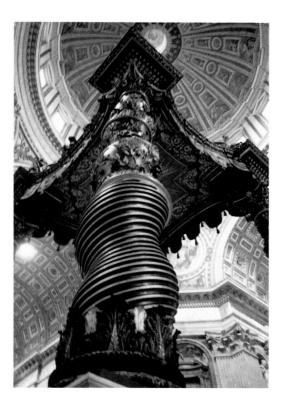

The Baldachino
Saint Peter's, Rome

Helen Chadwick's Eden. The pool itself is a tapered ovoid, in the same proportions as the artist's hand, and the spheres also decline stereometrically in scale with her fingers. In their goldenness, their harmony, their timelessness, integrity of shape and impregnability, the spheres represent the ideal, in contrast to the labile forms in the flux; they hark back to the Euclidean solids in which she set her memories of childhood in 'Ego Geometria Sum', but their immediate source was the Atomium, put up for the World's Fair in Brussels in 1950, and Belgium's rival to the Eiffel Tower. The hidden structure of the once-irreducible element of life, the atom, points us towards eternity and the absolute, in spite of the *lacrimae rerum* the work otherwise dramatises. The companion

piece 'Carcass', a tower of glass, is filled with compost, much of it detritus from the vegetable and animal matter used for the swags above the columns and the figures' attributes in the pool. It stands at the other end of the orbit of regeneration and death 'Of Mutability' traces. From the imperishable gold of the spheres to the column of rotting and life-giving matter, Helen Chadwick's piece takes us on a Pythagorean journey through the humble metamorphoses of the life-cycle.

Proud Change

1.
Primo Levi,
The Periodic Table,
trans. Raymond Rosenthal
(London, 1985)
pp. 33–4.

Primo Levi, the Italian chemist and author who was imprisoned in Auschwitz during the war, recently commented on the properties of the element zinc, and wrote in 'praise of impurity, which gives rise to changes, in other words, to life . . . In order for the wheel to turn, for life to be lived, impurities are needed, and the impurities of impurities in the soil, too, as is known, if it is to be fertile. Dissension, diversity, the grain of salt and mustard are needed.'[1]

'Of Mutability' praises impurities, from a different vantage and with different imagery, but for the same reason; because they bring about change. Helen Chadwick considered calling the piece after the first words of Spenser's 'Ode of Mutability' at the end of the *Faerie Queene*:

> *Proud Change (not pleased, in mortall things,*
> *Beneath the Moone, to raigne)*
> *Pretends, as well of Gods, as Men,*
> *To be the Soveraine.*

The artist creates her reverie of metamorphosis in a place of *'tamed nature'*, an enclosed garden or earthly paradise, natural and architectural at once, a world of enchantment, *'a safe place, within walls.'* Influenced by William McClung's 'The Architecture of Paradise,' a study of the heavenly city Jerusalem and the garden of Eden, Helen Chadwick interprets his comments on Eden in 'The Oval Court': 'As an equivalent of Jerusalem, it is a city that has acquired a garden – a garden whose natural properties, like the bodies of the resurrected dead, are apotheosized by incorporation into the "artifice of eternity". Viewed from this angle, the claustral garden is anticipatory and celebratory, rather than memorial and ironic.'[2] It is also a garden of knowledge, and of the delights that knowledge brings, a 'Hortus Deliciarum', like the title of the medieval illuminated encyclopedia, a lost marvel of the twelfth century, compiled by nuns under the supervision of their abbess Herrad of Hohenburg in Germany.

2.
William McClung,
*The Architecture of
Paradise, Survivals of
Eden and Jerusalem,*
(Berkeley, 1983),
pp. 24–5.

Helen Chadwick's earlier intimations of a heavenly enclave crystallised when she went to Munich and saw the pilgrimage churches of the Bavarian countryside, especially Die Wies, by Domenikus Zimmermann.

'It was just before Easter, and there was still plenty of snow . . . in Die Wies everything inside dissolves, you're in a space that defies architecture, that melts. I saw the melting snow outside, the melting stucco inside, as allegory: the church is dedicated to a statue that wept, and the rocaille wasn't just a decorative device but related to the thaw and the landscape and the passion, to the melting of the snows at Easter and to rebirth.'

The first wholly rococo church in Bavaria, at Steinhausen, by Domenikus and his brother Johann Baptist Zimmermann, also influenced her, but the ornamental exuberance of 'The Oval Court' was inspired above all by

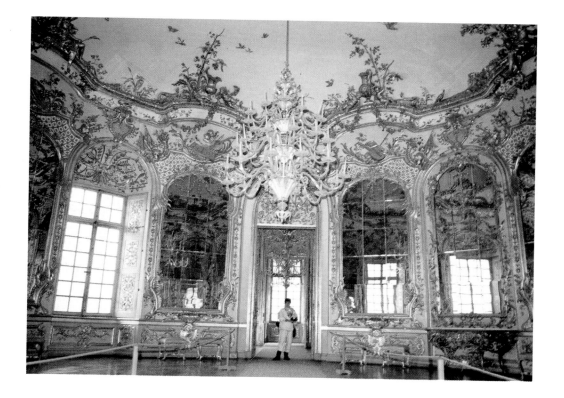

Spiegelsaal, Amalienburg, Munich 1734–39

the Amalienburg, a folly of a tiny palace built in 1734–49 by François Cuvilliés for the Electress Amalia, and by its Spiegelsaal, a silver and blue hall of mirrors.

'It's dizzy, like a kind of dance, and there's no sense of function at all. It's a place that began as a dream, a confection, but a confection made as a gift of supreme artistry. All the architect's resources went into manufacturing a dream reality. The rococo is incredibly light, and optimistic. It's not about power but about pleasure. It's unique – an attempt at finding a spiritual path through a pleasure principle.'

The Feather and the Bubble

'Of Mutability' seeks to communicate plenitude, taken at the cusp before its passing, like the Easter snows of Die Wies. This condition of ripeness, foreshadowing its own end, governs the elements in the Vanitas paintings developed in Holland in the seventeenth century. Of all the many influences at play in Helen Chadwick's work, this imagery of Vanity, taking its cue from the opening of Ecclesiastes – 'Vanity of vanities, says the Preacher. All is vanity' – has inspired the artist most profoundly in her choice of subject matter, although the rococo spirit of the piece, its aims of giddiness and rapture, has itself rung a proud change on the usually glum convention.

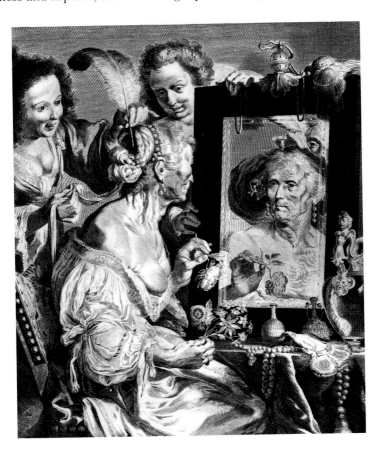

Vanitas
Jeremias Falck 1619–77
Engraving

Nature morte, dead nature or still life, includes the Vanitas as one of its species. Usually, there are three orders of objects present, painted with a mapping concentration on detail and instance of form, as if attention to the quiddity of things heightened the melancholy of their ephemeral duration. A superb example, Maria von Oosterwyck's 'Vanitas' of 1688, in the Kunsthistorisches Museum, Vienna, includes the symbols of an industrious life – books, scientific instruments, and artist's tools; the accoutrements of worldly luxury and idle pursuits – cards, coins, brimming goblets, musical instruments; and, in the third category, the one that has fascinated Helen Chadwick above all, the emblems of passing time – fallen petals, bruised fruits, withered

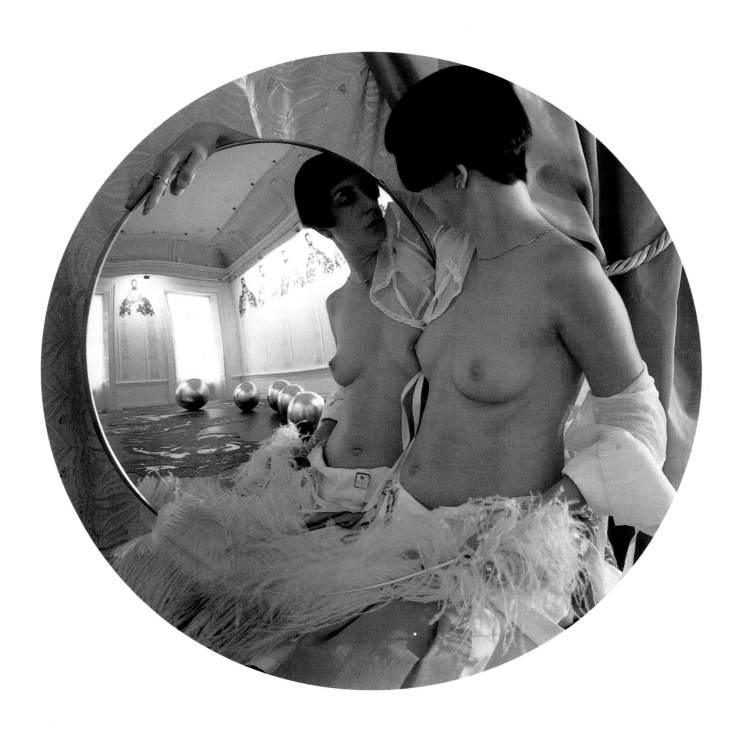

Vanity

Cibachrome photograph

60 × 60 cm

grasses, the moulted feather that floats on the slightest stirring of the air, the soap bubble. For just so fragile and fleeting and inconsequential is the life of a man, proclaimed the mottoes: *homo bulla*, some rubrics ran, man a bubble.

Helen Chadwick sees her figures in the pool as still lives: the animals in the collages were only very recently living. The lamb, the skate, the monkfish, the rabbits, the crab, squid, sardines, and the goose which appear to dance and even fly in the embraces of the Lover in the pool have passed into a dreamscape where their existence is no longer actual but only remembered. As Max Friedlander wrote, 'Still life can be a symbol of life in flower, or equally it can be the symbol of ruin and death.'[3] To stress the sense of transience, Helen Chadwick assembles around the major motifs of these allegorical couples the emblems of further mortification: from the hand of the ecstatic figure whirling with the goose, maggots from the bird's lights are falling; the double-headed figure of Harvest faces one way to ripeness and bounty, the other towards decomposition; the frivolous ribbons, lacy frills, frothy trailing trimmings and net tights, the schoolgirl socks and other ornaments echo the fripperies of Vanitas paintings.

3.
Max Friedlander,
The Connoisseur of Art
(London, 1955),
p 8, quoted in Alberto Veca,
Vanitas Il simbolismo del tempo
(Bergamo, 1981), p. 176.

'But the draperies aren't there as titillating lingerie, but to intensify the decorativeness, because the greater the decoration, the greater the sense of transience. Austerity implies endurance . . .'

'The Oval Court's imagery discards all the cultural artifacts – except luxurious dress – commonly found in Vanitas paintings, the cards, money, tools. But Helen Chadwick also places a great distance between her roots in that convention through her introduction and use of the nude. When individuals appear in Vanitas pictures, they meditate solemnly on mortality: Mary Magdalen and St Jerome with skull and burning candle, or the pensive sable-hued subject of Lorenzo Lotto's portrait in the Galleria Borghese, Rome, who trails rose and other flower petals from his hand, do not exult or spin or swim buoyed up by longing and rapture like Helen Chadwick's figures. Her sirens invert the usual stern message against the world and embrace worldly beauty and corruption instead.

Indeed, the Vanitas image refers explicitly to the female vice of vanity, and, as in the engraving by Jeremias Falck after Jan Lys's painting, from the mid-seventeenth century, the personified vice includes lust within its meanings. The image in this case bears an alternative title, 'The Old Procuress'. In such a work, woman sins when she adorns herself, because the objective of her vanity is the satisfaction of her lust; the same appetites that may be wicked in youth become unseemly folly in old age, and the allegory of Vanity then becomes a warning against foolishness of another sort. The Vanitas genre, rooted in northern European Calvinist reform, chastises women in particular for their addiction to pleasure. Allegories of the Five Senses, for instance, another species within the tradition, are modelled on the parable of the Five Foolish Virgins in the New Testament, who improvidently failed to fill their lamps with oil and so missed the wedding feast with the heavenly bridegroom. In a painting like the Claeissens panel in the National Gallery, Ottawa, the Five Senses, like the Five Foolish Virgins in Renaissance imagery, indulge the pleasures of this world – feasting, listening to music, the scent of flowers – while to symbolise Sight, the central figure gazes at herself in the mirror, like an allegory of Vanity.

'The Oval Court' also creates a complex allegory of the senses, and its imagery, representing experiences of all five, also excites them in the spectator, who easily imagines sounds of the lapping and falling water, the smell, even stench, of the tripe, the goose's entrails. The lamb, the rabbits make tender appeals to touch, while the hands in the monkfish can produce quivers of abhorrence. As in Hopkins's poem: 'Flesh and fleece, fur and feather . . . Sod or sheath or shell'[4] are recorded here, with more disquiet than expressed in Hopkins's hymn to spring, for his creatures breathe whereas Helen Chadwick's are still: the spoils of nature heaped for our pain or our delight.

By flourishing as the dominant and most visible motif the nude image of the artist herself, photographed directly by the copying machine and then assembled into *'a long-limbed, healthy, idealised'* form, slightly reduced from life-size, Helen Chadwick has conducted the Vanitas genre in a different set of harmonies. The human body has usually been placed outside the frame; the desire for possessions, the lust for worldly goods and for beauty that the Vanitas excites and castigates at once are usually set alight in the beholder, in us who stand before the picture. But in 'The Oval Court', we see the artist as beholder, as consumer, as desirer, as the one who leaps and gluts and feels and gorges and makes herself over to pleasure in a deliberately provocative display of the female nude.

One of the difficulties 'Of Mutability' presents arises from the artist's conscious, risk-taking game with the boundaries of the literal and the metaphorical as she searches for the iconic equivalents of sensation. The noose that bends the body in the Cornucopia panel as if stringing it like a bow from neck to foot, the hood that masks the face in the Goose panel, the spool that unwinds from the intestines of the Harvest figure and the little axe that cleaves her pubic triangle intentionally apply the imagery of sado-masochistic practices to conjure sensation.

'She is gagging with pleasure,'

says the artist, of the tied Cornucopia figure.

'She's bursting out of the basket, and fruit is bursting out of her.'

As Jane Gallop has observed regarding the presence of the female body in text, there persists 'a difficulty in accepting the body as metaphor, a demand that metaphors of the body be read literally.'[5] In image, the same question becomes acute: the eye of the body does not sift the appearance of a figure in a noose or hood to part the metaphorical component from the enacted pose, as the mind's eye does automatically when presented with the most commonplace phrases: 'I felt bound hand and foot,' 'The wind sliced through me like a knife,' 'I was burning with embarrassment.' This asymmetry between language and image has been intensified by the realist tradition, especially in photography, the medium Helen Chadwick is chiefly using to compose 'The Oval Court'. When a *quattrocento* altarpiece shows St Peter Martyr, for instance, standing upright and serene among the blessed with an axe through his skull, the image reminds the spectator of the way he died a martyr, but does not describe his physical condition in heaven. When seven swords transfix the bleeding heart of Our Lady of Dolours, the faithful know her sevenfold grief at her son's passion. Helen Chadwick is exploring

4.
'The May Magnificat',
in *The Poems of
Gerard Manley Hopkins*,
(Oxford, 1948), p. 82.

5.
Jane Gallop,
'Writing and Sexual
Difference: the Difference
Within', in
*Writing and Sexual
Difference*,
Ed. Elizabeth Abel
(Brighton, 1982), p. 288.

metonymy of this sort, in awareness of its frequent sacred context. She wants to express the invisible profane, as dearly as the religious painter sought to body forth the invisible and holy. But she also recognises the controversial character of some of her dreamers' emblems, and though aware – mischievously aware – of their associations and the criticism she could attract, she experiences a psychic need to defy restrictions of all kinds, to break the bans on pleasure in her garden, to disturb and to include everything in her reconstituted self-image, to make portraits that leave nothing out.

The body in the pool takes up impossible positions, like a baroque angel. Yet sometimes, the artist has deliberately borrowed poses from famous displays of women: the swoon of Bernini's St Teresa when the seraph pierces her breast inspires the group of lover and bird in the Goose panel, the notorious show of rump by Mlle O'Murphy in several Boucher paintings is reproduced by the swimming figure beside the cluster of ribbons and fringe – though with the divan missing, we do not read her as inviting entry like her famous prototype.

The made objects – cords, lace, veils – stir problematic responses of a different kind from the animals. The lamb, paschal and so sacrificial, meets the vaulting lover face to face in a kiss. A literal reading of this image would be manifestly ridiculous, and the resulting wealth of emotive metaphor that the image of their embrace generates will vary in value and depth for each spectator, striking up in each of us different resonances, happily and unhappily, satisfyingly or bafflingly according to personal memories and dreams of desire.

Both the artifacts and the creatures in '*the cornucopia of clutter*' in the pool represent knowledge the lover wants. In her paradise after the fall, Helen Chadwick has accepted at face value God's declaration as he expelled the first humans that they have become as gods, to know good and evil. But she has inverted the familiar moral, that shame accompanies knowledge, and her paradisal woman has no shame, she shows herself and revels in the show.

She offers herself to the machine that made her picture, and then to the gaze of all; but the relations of power between voyeur and subject are altered. Unlike a pin-up, she is in charge of her image. Her embrace of such an abundance of nature – the skate and the maggot, the olive and the fig, the gizzard and the seaweed frond – cast her, the lover in the piece, as a *domina*, or mistress of creation, and her beloved as the creatures around her, offered like her, like first fruits, to our gaze. Yet it comes as a shock to realise that all the creatures present are edible. The shared meal, as the Greeks knew, follows the sacrifice. The relations between the animals and the Lover are not violent, however; the pool is womb-like, amniotic, their swimming dance in it evokes sensuous, languorous sensations, not thirst for victory or consummation or even orgiastic exhaustion.

Love's Mirror

The melting illusions of baroque churches and palaces inspired 'The Oval Court's arrangement, and the baroque painters of the nude with their giddy *sotto-in-sù* perspectives have influenced the protagonist's exuberant poses. Helen Chadwick has turned the ceiling conceit upside down: instead of looking up at an imitation of heaven, we

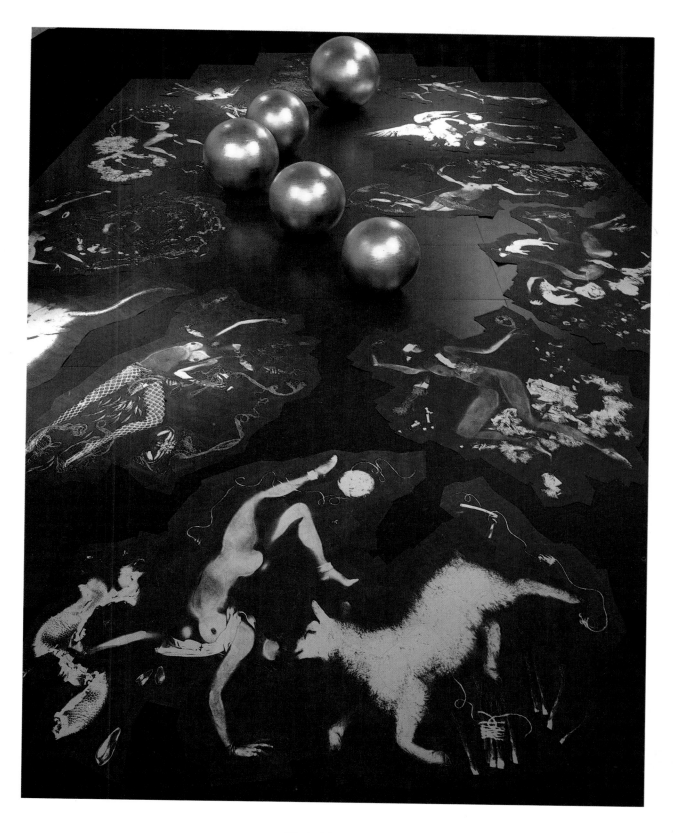

The Oval Court (detail)

look down upon the free play of the nude in the element of water, not air. The allegorical nude soaring upwards in baroque painting might be identified as the goddess of Love, as in Tiepolo's apotheosis 'An Allegory of Venus and Time' in the National Gallery, London, or sometimes Beauty personified, or sometimes Truth because, as Cesare Ripa wrote in his influential handbook for painters, the 'Iconologia' of 1602, 'every Virtue is an appearance of the true, the beautiful and desirable, in which the intellect takes its delight, and as we commonly attribute beauty to the ladies, we can conveniently represent one by the other . . .'[6] Truth is the 'naked' truth, *nuda Veritas*. The

<div style="margin-left:2em">

6.
Cesare Ripa,
*Iconologia overo Descrittione
delle Imagine Universali*,
(Milan, 1602), p. 90.

</div>

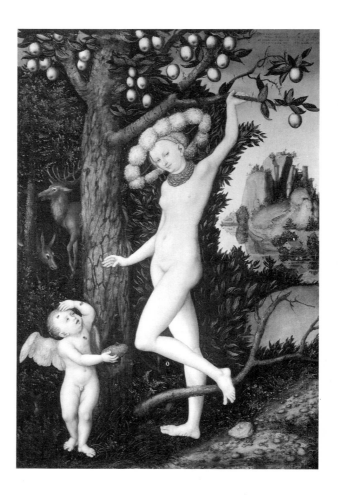

*Cupid Complaining to Venus
Lucas Cranach the Elder
1472–1553*

sculpture of Bernini shows her rising from the folds of Time that had kept her hidden – 'under wraps' – with a radiant smile on her face and a rapturously eager upward movement of her limbs. Bernini made truth beautiful because 'the most beautiful virtue in the world consists only of truth.'[7]

7.
Irving Lavin,
*Bernini and the Unity
of the Visual Arts*
2 vols. (New York, 1980),
vol. 1, p. 73.

Truth however must be entirely naked, to be the whole truth with nothing to hide. Ornaments belong to Venus, who as we know from Cranach's enamel bright paintings wears frivolous hats even when she has nothing else on. However Venus and Truth frequently hold an attribute in common, a mirror. Truth's mirror has been borrowed from Wisdom, who is called in the Bible the *speculum sine macula*, 'the unspotted mirror of God's

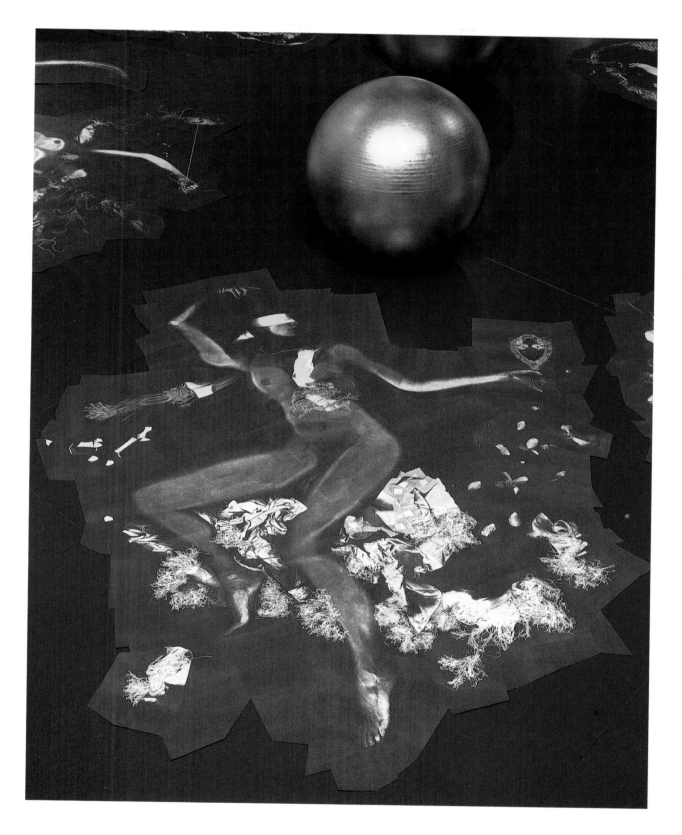

The Oval Court (detail)

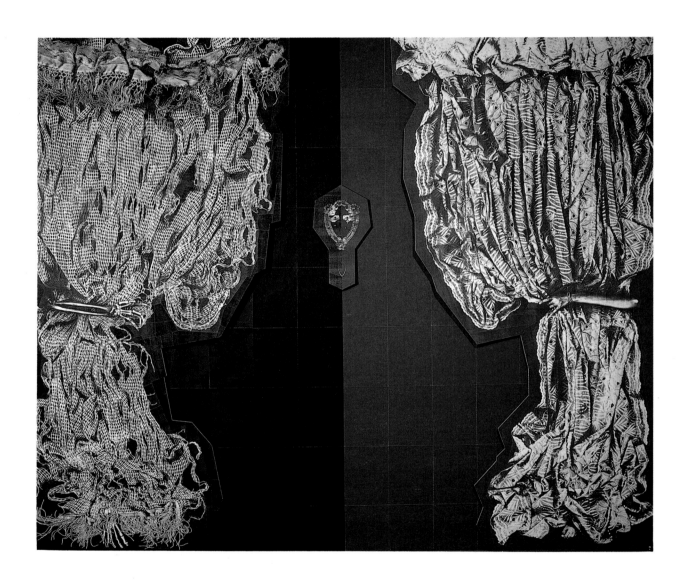

Vanitas

Photocopies on board

240 × 290 cm

active power, image of his goodness' (Wisd. 7: 25–6). Ripa explains, 'The mirror teaches us that Truth has arrived at the moment of perfection when … matters of the senses conform to those we see with our mind, just as a mirror is good, when it reflects back the true form of the thing that shines in it …'[8] The Virgin Mary, in her Wisdom aspect, sometimes appears with a mirror as one of her attributes, as in Tiepolo's soaring 'Immaculate Conception' in the National Gallery of Ireland; nevertheless, it is easier to accept a looking-glass as the emblem of Venus. From antiquity it has been associated with her; on the bronze hand-

8.
Ripa, Ibid. pp. 285–6.

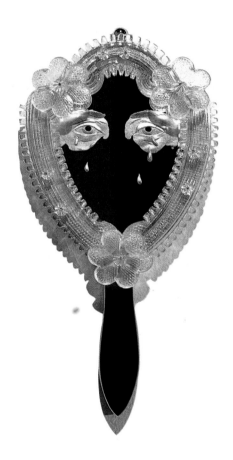

Vanitas
Engraved mirror and Venetian
glass 30 × 15 × 2 cm

mirrors in the British Museum, her children, the erotes, are flying around the edge.

One of the figures in the pool holds a mirror, and it reappears at the fulcrum of 'The Oval Court', in the centre of the colonnade. The reflected eyes on its surface are weeping, like the heads above the columns: the mirror of Venus is also the mirror of vanity and folly. This symbol, Love's mirror, carries us to the heart of Helen Chadwick's 'Of Mutability'. For the Beloved is not Other, the embraces in the pool do not posit another being, the animals are not Other either, but represent the mutiplicity of selves within the Lover and of shades in the experience of Love. The drama of 'Of Mutability' is taking place within the subject, the One scattered and

splintered and restored over twelve matrices. Helen Chadwick responded with warm recognition to reading Julia Kristeva on narcissism: 'If one were now closely to observe not the myth of Narcissus but the speculative space which is its near contemporary, particularly Plotinus's neoplatonism, one becomes aware of an enormous effort invested in reformulating this drama that I would no longer call narcissistic . . . but narcissian. This reformulation consists in the following: instead of self-inculpation, instead of feeling unhappy before your image, which you cannot and must not love, go ahead – love yourself . . . From this moment on, the confrontation of man with his image [Kristeva's phrase] undergoes a transformation, becoming the solitary communion of hands

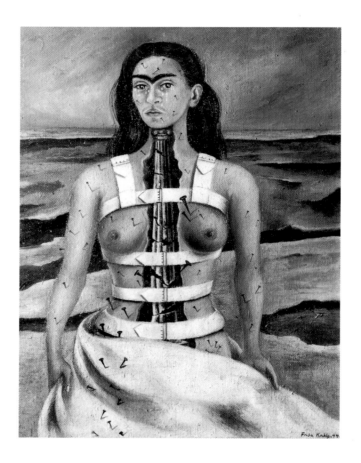

The Broken Column
Frida Kahlo 1944

clasped in prayer. Henceforth introspection becomes a right, thus permitting the constitution of an individual psychic space . . . Introspection, which is always to some extent amorous, is possible because you love The One and The One loves you, lacking which condition you have no right to this reparatory and consolidating self-contemplation. It is by virtue of love that this space is strengthened, and by virtue of such a psychic space that you are able to brave disappointments, hard blows.'[9]

 Helen Chadwick has written, 'Art, like crying, an act of self-repair, to shed the natural tears that free us, make us strong' . . .[10] Her piece, in which pleasure and pain, joy and grief cohere, enacts a narcissian

9.
Julia Kristeva,
'Histoires d'Amour – Love
Stories', in *Desire*,
Ed. Lisa Appignanesi
(London, 1984), p. 19.

10.
Helen Chadwick, *'Revisions'*
Cambridge Darkroom 1985.

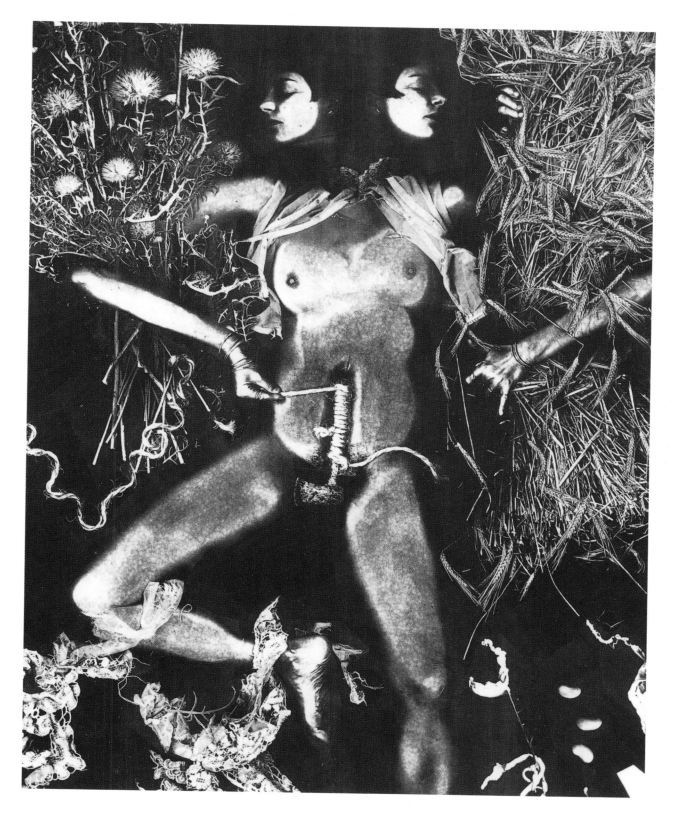

The Oval Court (detail)

love that dissolves opposites in the quest for fullness of feeling.

The Greek myth of Narcissus also tells the story of Echo, the nymph condemned never to enunciate by herself, but only to repeat what another says: it was her punishment for earlier, dazzling storytelling. The nymph Echo stands for the generic feminine in the work of Max Ernst, for instance, and also for the condition of the artist through whom the world passes and by whom it is reproduced. Deprived of autonomy, necessarily secondary, a receiver who cannot give out messages of her own, Echo, like the traditional female image in art, becomes a conduit for others' words and thoughts. She receives the imprint of external desire, does not articulate her own for herself.[11] In the case of an artist posing for herself as model, the emotions represented in the image issue from the speaker or the maker since they are one and the same: the short circuit of the self-portrait makes the original voice and its echo indivisible.

The nude self-portrait seems to exercise a special fascination for twentieth-century artists, male and female. In varying ways Frida Kahlo, Leonor Fini, Nusch Eluard,[12] and in Helen Chadwick's generation Roberta Graham and Penny Slinger have explored the exchange of glances when the artist interrogates her own nakedness in the mirror. In 'Of Mutability', Helen Chadwick invents the reflections in a pool of love, like the pond in which Narcissus saw himself, by using an actual glass, the reproductive reflector of the photocopier. The images she produces reach towards the state of simulacra, because they do not imitate corporeal reality but copy it directly off her body and other forms. Yves Klein took prints off models when he dragged them across canvas or paper in his 'Painting Ceremonies'; George Segal cast in plaster from life. Helen Chadwick's photocopying achieves a similar frisson to Klein and Segal's experiments with simulacra because, as with reflections in a mirror, as with echoes off water, the imprint is taken from life, the original must be there in the first place: in 'The Oval Court's Elysian Fields, all things are real.

Real, but not alive. As original images, authenticated by their contact with the artist or the creatures' *physis*, they set up tension in the beholder through their stillness, their mockery of life and death through their appearance of life-in-death. Her own image on the paper partakes of the condition of *nature morte*, that of the creatures around her; and the first corpse is the picture itself.

The Nature of Her Body

Like a Renaissance allegory of Abundance, the figures of 'The Oval Court' hold cornucopia overflowing with the fruits of the earth and the sea; the artist shows herself in what used to be called 'natural splendour', and has discarded the paraphernalia of culture, except for the ornaments which accentuate her nakedness. Sympathy flows between the female subject and her animal familiars, and the irregular, organically swelling collages in which she drifts form a contrast to the regular spheres and computer-drawn columns, as if her feelings were counterpoised to reason. In her notebooks, Helen Chadwick quotes Frida Kahlo's 'the vegetable miracle of my body's landscape', and like that artist, she uses her own body as the site of identity and its puzzles.

11.
See Froma I. Zeitlin, 'Travesties of Gender and Genre in Aristophanes', *Thesmophoriazousae*', in *Writing and Sexual Difference*, op. cit., pp. 146–7.

12.
See Whitney Chadwick, *Women Artists and the Surrealist Movement* (London, 1985), p. 144.

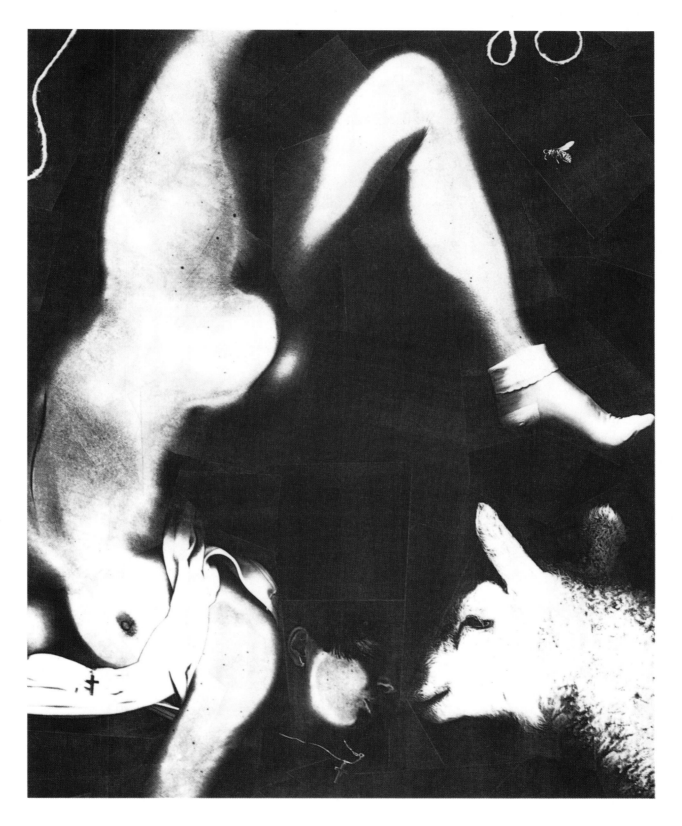

The Oval Court (detail)

'Progress has to be made through self-understanding, self-awareness, but one of the taboos has been an exploration of one's own body. To understand the capacity for transcendence through the flesh, one has to move in the face of theory into areas that cannot be comprehended by theory. I want the body to be as much a site of victory as the brain.'

13.
See Hayden Herrera, *Frida A Biography of Frida Kahlo* (New York, 1983).

Whereas Frida Kahlo's meditations on her states of being are intensely poignant, even tragic, as in 'The Little Deer', in which she sees herself as a doe, stuck full of arrows, or in 'The Broken Column', in which she reveals her shattered spine inside a surgical corset, like a Man of Sorrows,[13] Helen Chadwick's plural autobiographical selves do not communicate personal experience and actual incident with the same intensity, nor are they intended to; there are areas of somatic female experience – maternity above all – that 'Of Mutability' deliberately does not enter. The artist does not hymn the cycles of women's bodies in an essentialist manner, or lament specificities of female suffering – barrenness, for instance. Also, her love of artifice in the processes of production casts a mood of deliberation and control over her work, however ecstatic and unbridled individual figures in it may appear. But the choice of imagery brings her close to making a claim that the female sex enjoys a special relation with nature. Helen Chadwick qualifies the concept of 'nature':

'Central to the idea of the garden paradise is the female body, as a fundamental element of nature, the embodiment of nature, not in the sense of 'Mother Nature,' but as a projection of self.'

By juxtaposing the nude with animals and fruits and other delights for consumption, 'Of Mutability' enters the Arcadian tradition, which promises bliss and benediction through the unity of all creatures and the erotic languor of the nude. Venus lies with a dog at her feet curled up on her bed while birds alight outside her window in Titian's famous nude in the Uffizi; Diana hunts with her hounds, the trophies of the chase by her side, in Boucher's painting of 'Diana Bathing'; a black cat has jumped on Olympia's bed in Manet's painting. (At the time, its presence provoked an uproar against such filth.) 'Playmates' are 'Bunnies' and 'Pet of the Month'.

The erotic woman also arouses 'animal' feeling: sea-monsters menace maidens, like Andromeda, as in Titian's painting in the Wallace Collection, London. Helen Chadwick's skate with its gaping maw, or her monkfish with its yawning jaws spring from her fantasy, and do not threaten to devour her but rather to give birth to her in new form; yet they still recall the mythical monsters of the deep with which women have been painted and sculpted, naked, bound, and full of passionate and stimulating terrors. When the artist cleaned and groomed and washed the creatures she photocopied in the course of making 'Of Mutability', she grew to love them, the lamb and the monkfish, skate and rabbit alike. She praises the monkfish's lips, the skate's genitals. Nothing animal is alien to me, she might say. Like the engraving of Nature by Gravelot & Cochin in the 'Almanach Iconologique' of 1766–74, who stands naked in an earthly paradise with a stag and a lion at her feet, the female subject of 'Of Mutability' is at one with nature. But unlike the self-proffering nymph of Gravelot, the nature Helen Chadwick pictures has not tamed the wild. She has no desire to domesticate.

'Of Mutability' unfolds the connective tissue between women and nature much more disturbingly;

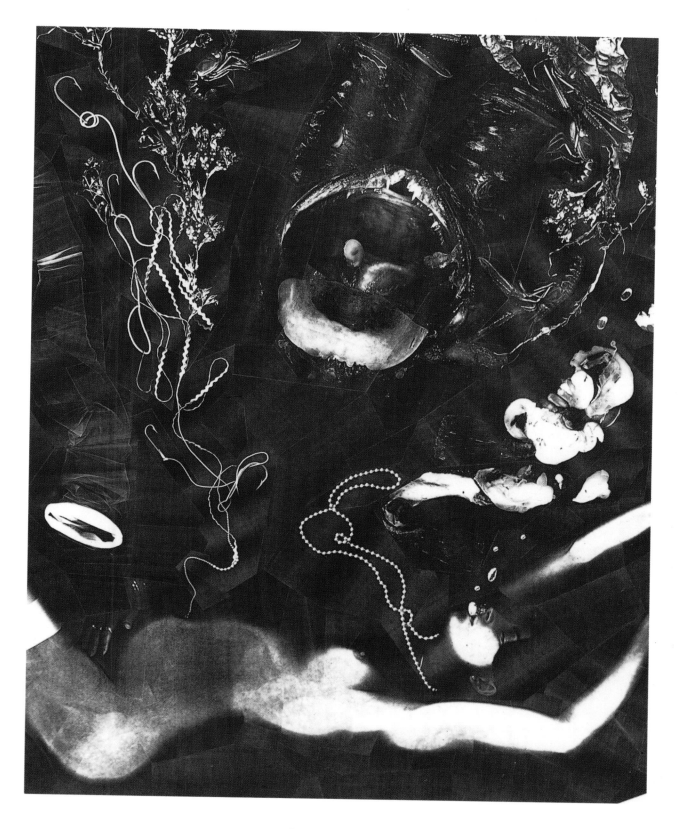

The Oval Court (detail)

and the medical metaphor is carefully chosen. Anatomical presentations, in which female bodies are opened for inspection, have inspired Helen Chadwick's own inquiry into her inner being. She lays out her psyche, penetrated and traversed, saturated and 'shafted' by passions *in extremis*, by making images of bodies opened to sensory experience in the same way as medical illustration reveals the internal organs of woman on her belly. Whereas the traditional Vanitas meditated on bones and crania, Helen Chadwick turns her eyes to entrails. She wants innards to express interiors: again, the dominant and problematic metaphor of the body returns.

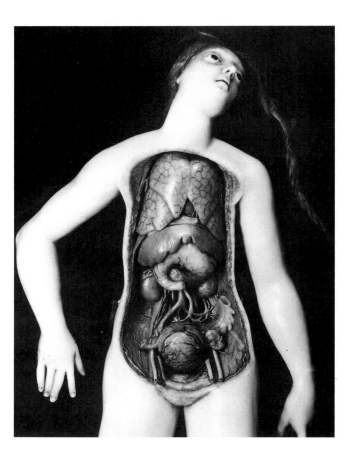

*Female Anatomical Figure
French 18th Century
Wax Teaching Model*

'The drapery is like a kind of membrane, a feeling on the outside of the body. I've looked at the mouth as being something through which the interior can be revealed, and at the way the objects can be pierced or cut in some way so that they're not closed.'

She can approach the necrophiliac's rhetoric when she praises *'the inner surfaces and structure, as delicate as the outer forms'* of the creatures she photocopied for the piece. And while working on 'Of Mutability', she recognised a parallel in the ancient practice of haruspication, or divination by the inspection of animal entrails in Etruscan and Roman cult. Again, her images are sacrificial, oracles for us to decipher as we can.

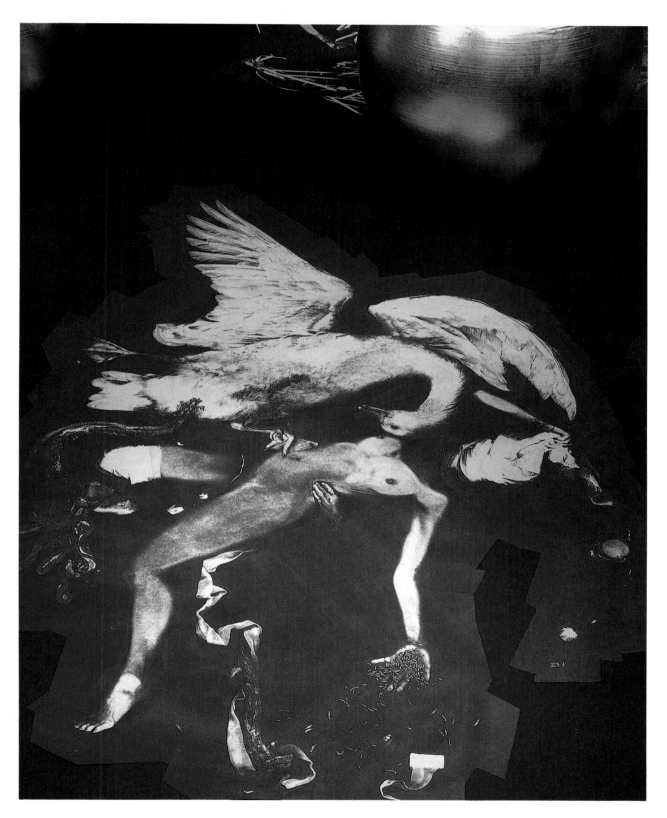

The Oval Court (detail)

'On Being Blue'

In 'One Flesh', a variation on a Madonna and Child by Van Eyck, made while working on 'Of Mutability', Helen Chadwick perpetrates a Surrealist-type outrage, by placing the placenta as a halo and blazoning the infibulated labia of her friend, the mother in the picture, at the apex of the altarpiece. By contrast to this, 'The Oval Court' creates a sanctuary of pleasure, in spite of its repeated memories of mortification. 'One Flesh' is primarily red, and redness has its own set of passions; the blueness of 'The Oval Court' makes all the difference.

'It was always blue, right from the beginning. I was drawn to blue – the thing I most identified with, in the rococo, was the sense of a transfixed reality that's constantly pulsating within itself. And that's achieved by rhythms and asymmetrical, sinuous line, and it seemed to me that the colour where one cannot determine gravity or perspective is blue – it's the only one because of its suggestion of sea and air.'

Blue is the colour of transcendence, of the Madonna, 'the sapphire who turns all of heaven blue' in Dante's 'Paradiso',[14] but it is also the colour of the blues, and of the unknown ('out of the blue'), of emergence, and of blue movies and talking blue and of bruising and cold. The philosopher William Gass, in his essay 'On Being Blue', says that 'colour is consciousness itself, colour is feeling . . . Of the colours, blue and green have the greatest emotional range. Sad reds and melancholy yellows are difficult to turn up. Among the ancient elements, blue occurs everywhere: in ice and water, in the flame as purely as in the flower, overhead and inside caves, covering fruit and oozing out of clay. Although green enlivens the earth and mixes in the ocean, and we find it, copperish, in fire; green air, green skies, are rare. Gray and brown are widely distributed, but there are no joyful swatches of either, or any of the exuberant black, sullen pink, or acquiescent orange. Blue is therefore most suitable as the colour of interior life . . .'[15] The condition of being blue, Gass suggests, must be the condition of art: pressing towards the unspeakable, the melancholy and obscene, and at the same time transcendent, paradisal. Scarlet calls up heat and fire; but the ambiguities, the edges, the gaps of feeling are blue, and in its tonal range it comes closest to synaesthetising passion.

Helen Chadwick's 'Of Mutability' makes images of profane feeling, which both print themselves on the body of the subject, and are enacted by that body, thus fulfilling the passivity implied by *passio*, as well as its activity of emotion. The use of the female nude as a template for a wide range of meaning strikes echoes off the high art tradition, as does the playful, almost prankish baroque of the style of Helen Chadwick's fantastic, bold creation. 'Of Mutability' is made up of echoes. Above all the artist admits us to the nymph Echo's new romance with her utterance, made partly of past images and now spoken with the once-fettered voice. She opens the gates on her earthly paradise where she got carnal knowledge, and through her exalted and sacrificial body, self-portraits in apotheosis floating in the elemental blue, she discloses her *passio*, and names her pleasure and her pain.

14.
Canto 23, line 102.

15.
William Gass,
On Being Blue
(Manchester 1979), pp. 73,
75–6

62

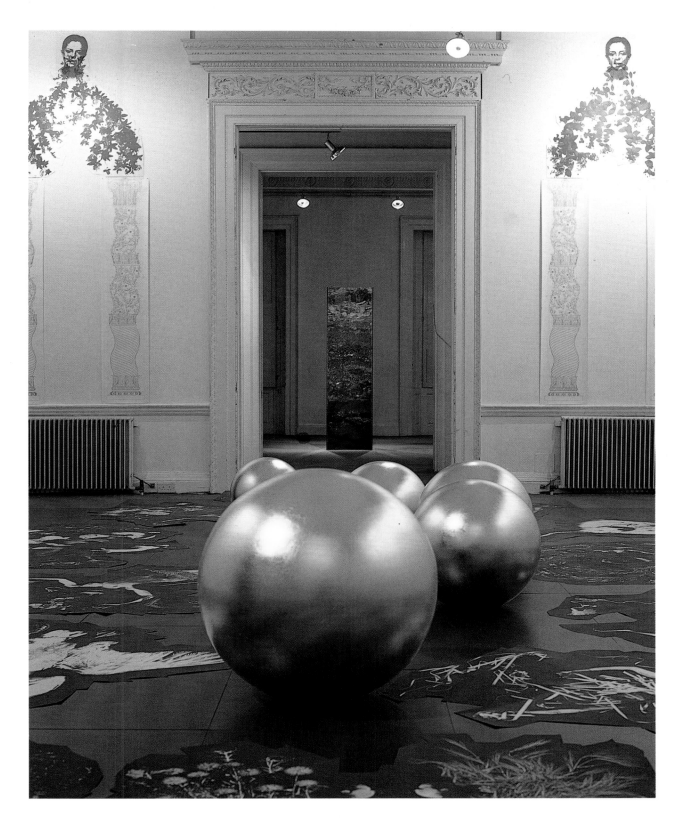

Of Mutability

The Oval Court & Carcass

Installation ICA, London

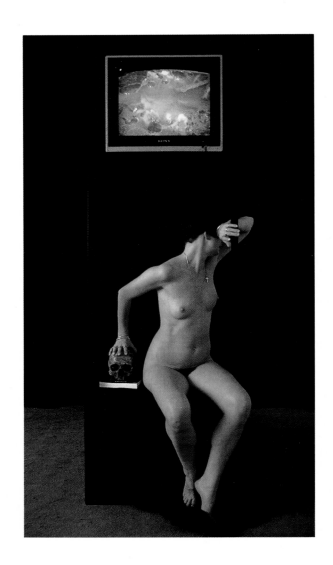

Ruin

Cibachrome photograph

91.5 × 40.7 cm

Carcass (detail)

Organic material and glass

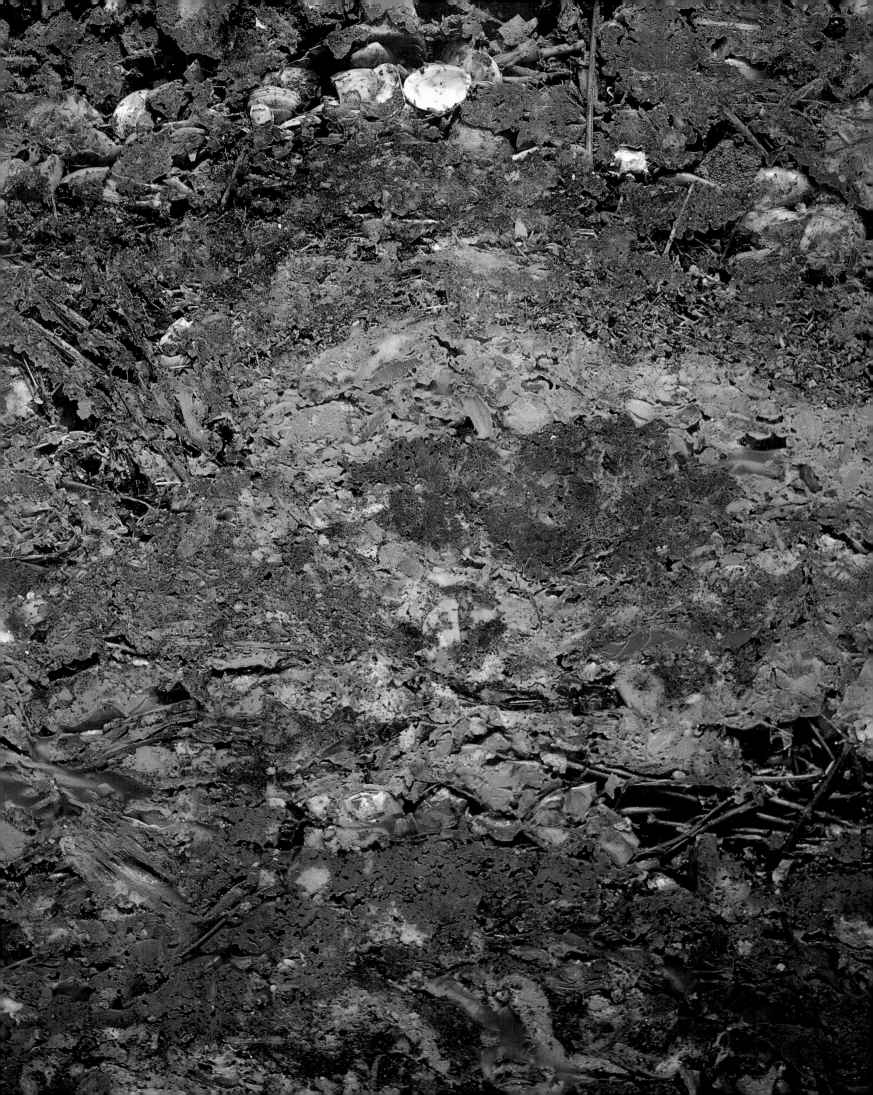

LUMINA

The first subjectivities flicker on the rock, animated by a glimmering lamp. Created out of the dark, by converting fire into non-consuming light, they emerge as the wick burns tallow. And thus are these images, these scratchings now manifest. It is the act of illumination that conjoins the prehistoric with the present, that permits a recognition. But of what? Vital familiars from the cradle, they are bright with origin. Their undeniable presence confounds the tyrannies of Plato's cave – the play of shadows gives the illusion of fresh movement, a springing into life. Yet these marks exist outside of knowing and, inexplicable in the fascination of being there, elicit a sense of distance in their very intimacy. These are ciphers that perpetually resist us, even as we are pleasured.

Perigord, July 1987

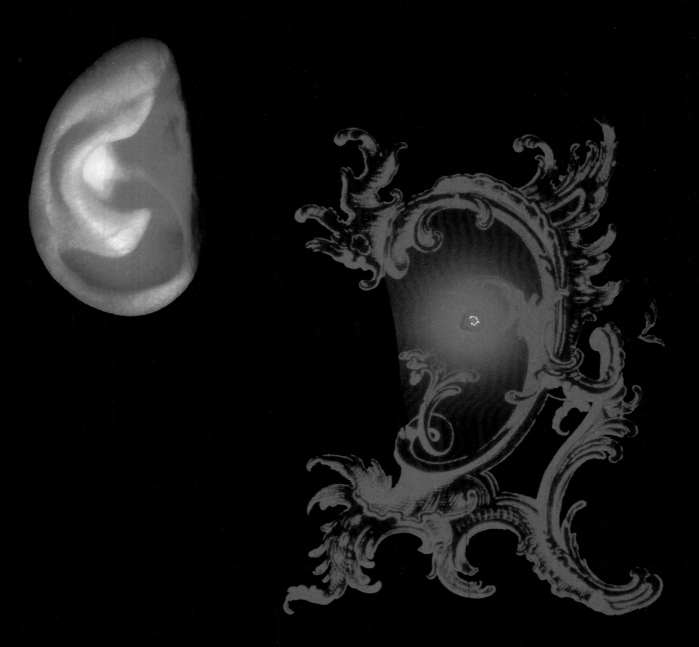

As arabesque or image, the projection of light on surface is more than a question of visibility. Given value by a warming beam, pigment and substrate seem to come alive. They shine. The radiance appears luminescent, not in its own right but as another superposed from within. This contact is reflexive energy thrown into being. For touch cannot be in opposition to itself, can never be perceived as surface or source, but an acknowledgement that actual is mutual – a conjoining of two. Mute in division, if broken into, duality here is akin to the complementary nature of light and opens up a field for the physical and specular. Their interplay is contiguous, like experience itself. Feeling oscillates, reciprocal as a pulse upon skin.

Causality is ended in synthesis, at the moment of simultaneity. But the sense of unity is in passage, a proposition achieved across distance – projections through space. Here co-existence is all contrived, poised, a deception founded on the suspense of touch. These works are contingent on delay and broach the impossibility of a full conscious materiality. For the field of vision is anticipatory or a negotiation after the event – the instant lies on a horizon, an immediate point that can never be grasped. Within the thrall of time, identity can only be affirmed from afar, through the awareness of separation in illusory couplings, for yearning belies all presence. Loss then is at the kernel of consciousness. The false caresses of the body of art by light itself articulate what can never be retrieved. There is no return, no consummation, but the pause of melancholia. The jouissance of loss is our only productive source, absence caught openly in the lapse of visual pleasure.

Tre Capricci

Tre Capricci

Leather, plywood and slide projection

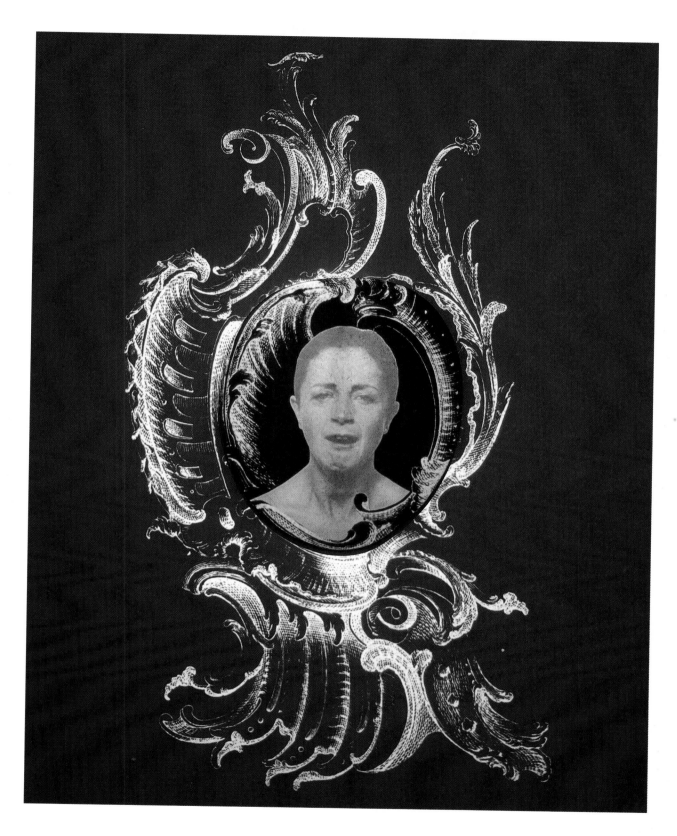

Tre Capricci (detail)

Leather, plywood and slide projection

155 × 81.3 × 4.5 cm

Allegory of Misrule

Stung by the whiplash of a monstrous catastrophe, I awake in the middle of the night, shocked to be present at the moment of complete termination. Just a bad dream, the persistent nightmare of our times. But feeling hurt and angry at having the peace of sleep ruptured, I began to wonder how I might stretch that terrible moment out, to comtemplate it and discharge its hold.

*Allegory of Misrule
Johnann Georg Platzer
1704-61*

I have always been fascinated by Platzer's *Allegory of Misrule*, a strange rococo painting. What if the two images were to coalesce, Platzer's dramatic scene upon the tragedy I was imagining in sleep? The central figure could then be my own, a self-portrait. I photocopied my body. In place of the original *putti*, a train of animal corpses issue from my garments as my only familiars. The oak tree unravels into locks of hair, splitting the skein of its double helix; a discarded infant's robe and bootees are left to dangle. Finally Nagasaki completes the transfiguration.

Emblems of destruction and survival. A prophetic vision in the mode of *Fantasia* or of *Revelations*? I would prefer a cautionary reading, asserting the sovereign right of every individual to confront the private uncertainties that oppress us collectively. As such, this work is a moral one, clamatory, and against a theory of the Apocalypse with its deterministic inevitability. The melancholic female is no longer Venus, nor even a Cassandra, but stands as an allegorical personification, perhaps akin to Conscience.

Platzer's *Allegory* now illuminates the surface of my own equivalent, spilling onto the black surroundings. Like a neon image, the fusion of the two seems to float in the indefinite space of night, a dilated Cinemascope, returning us to the drifting chimeras of dream.

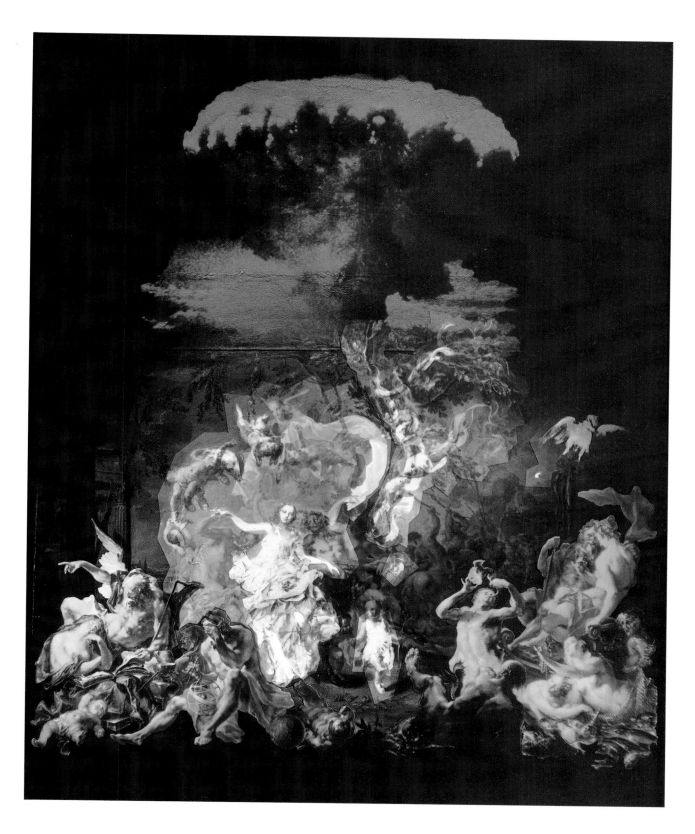

Allegory of Misrule

Photocopies on board, emulsion paint, slide projection

370 × 333 cm

Lofos Nymphon

Lines that severed, bind

The *Omphalos* is a large ornamental stone carved with knotted cords and strings. It marked the centre of the ancient world, the navel where East and West met at Delphi. Assured of a centre to their universe, the Greeks knew their source, gave it substance and a name.

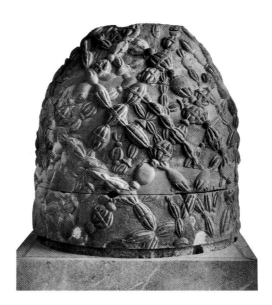

*The Omphalos
Delphi*

As a modern, with no centre, no core of belief, is it possible to encounter the void of Origin, to give it form and a body and so return to the site of beginning? Looking for such a place, might the maternal offer a locus, between birth and identity, there from the moment of separation. In irreparable division, the same human flesh is parted and we are at the threshold of being. Soft recollections of this early time, more space than duration, drift soothingly and far away in a sensory constellation of touch and smell.

The motif of the Mother and Child consoles our fall from this first hearth of pleasure promising a union beyond the one of flesh. Idealised and devotional, the Virgin's love is pure and unconditional. Of spotless body, she can return as bride and lover to her son. This is our Christian legacy. For a woman of human lineage to couple female with female is difficult, since embraces of love in sameness lie in the realm of the unspoken and forbidden. Even if there were new icons of filial devotion as models, such a 'pan-amorous' union although desired

is frightening. To return to the Mother might be engulfing and precipitate a fatal loss of self. And so a cycle of alienation, of never-to-return, is established, played out in a cat's cradle of irreconcilable yearnings and regret.

Facing open rupture, the wound of difference, what a solace it would be to construct a haven for the disembodied memories of pleasure at the mother's breast – a chamber where the oscillations of dread and longing merge together and I might resurrect this lost archaic contact safely, quelling my fear of her depths.

Once knots in the navel-string were used to prophesy the future. Here, looking back to the source of selfhood in that first and fatal life-giving cut, are five loci for reading, nodes on a thread, to re-evoke the egg, the cartouche of that swollen pendulous body. Together, out of sundered fragments, a portraiture woven of mother and daughter may be born.

Touching egg

The anonymity of the egg is a first encounter with my pre-history. Its presence as an object asserts a fundamental status as both body and place at the archaeological site of my being.

The five ovoids are pure colour, painted, but dissected into slabs and bands of light-consuming pigment. Hard and flat, these painted objects are principled unto themselves, existing under the discipline of their own metaphysical language. Yet simultaneously, they receive a patination of light, a photographic image which rests as a membranous film over the hard actuality of entity. In a passage from presence to figuration, in frail counterpoint, this subjective mirage shimmers on the surface of ruthless formalism. An intimate play of autonomy and merger, it is a queasy equilibrium. As the light irradiates the implacable substance of the egg, melting its severe geometry, a moment of synthesis is tentatively established and, in binary difference, a reconciliation proposed.

In this uneasy space between language and representation is a crease, a territory in which the early self unfolds. The landscape is all touch – its means, metaphors and picturings – to temper the violent pleasure of solitary looking. Perhaps through palpable contact we can trace a path back to the pre-lingual delights of childhood. Betwixt the maternal and the filial, in the curious luminous space of these cameos of light into matter, a pre-Oedipal reverie might be kindled.

On losing name and home

This language hovers between a personal and objective script – as my own image rests on the stuff of paint – in a strange theoretical no man's land. Perhaps it is timely to consider geography, *and* as the female noun *Geographia*. If the body in question is female, so also is this place, home, an inherited site.

At the top of a once-wooded hill in ancient Athens, formally dedicated to the Nymphs, my maternal great-grandfather built a neoclassical house for his daughter, as a dowry gift to be passed down the female line. The street in which it stood bore the name of that early allegiance: *odos Nymphon* – the road of the nymphs. As my mother left the city and lost her home, her name in marriage, a curious parallel occurred. The street lost its name and was given to honour a local dignitary, becoming *odos Dimitri Aginitou*. The historical continuum was broken, leaving a sequence of cuts unhealed.

At the heart of the city, the view from the house encompasses all Athens in a panorama from the Hellenistic roots and flowering of culture through to the founding of the new Greek state. From the *axis mundi* of this her former home, a series of historical prospects are disclosed, linked by the narrative cord of a balcony rail. By introducing our foregrounded body, I challenge the breaking of the female line. Let the monuments be eroticised and the very gender of the city called into question. Athens, appropriated by Western civilisation to legitimise its own structures, is always offered up as our cradle. But the model proffered is masculine, its female body politic, its African and archaic roots denied.

I call for the bodies of women to re-enter the stage of the city, to recast it at the edge of history and at the limits of representation, passing into vistas of presence unto absence, desire into *jouissance*. As the buildings allegorise our bond where flesh itself is petrified into living statuary, the horizon opens onto a *mise en scène*—ellipses of Otherness in which the female corpus is restored.

In the gentle ebb and flow of departure to return, separation to union, from daughter to mother to city, history and culture might happily admit to being feminised. As the sequence rotates from the centre-point of the eye of the camera, from the axial I of the house, turning and enfolding, we trace in *tondo* the passage of the day. From night through dawn to dusk, proceeds illuminated the approach of our re-membered body that is in unison the dome of the observatory, the church's breasts, the stomach of the Agora, the navel of the Acropolis and the genitals of the Pnyx. Pausing in the quiet melancholic drifts of daydream, I greet these fluctuating rhythms. Polymorphic rhythms of homecoming.

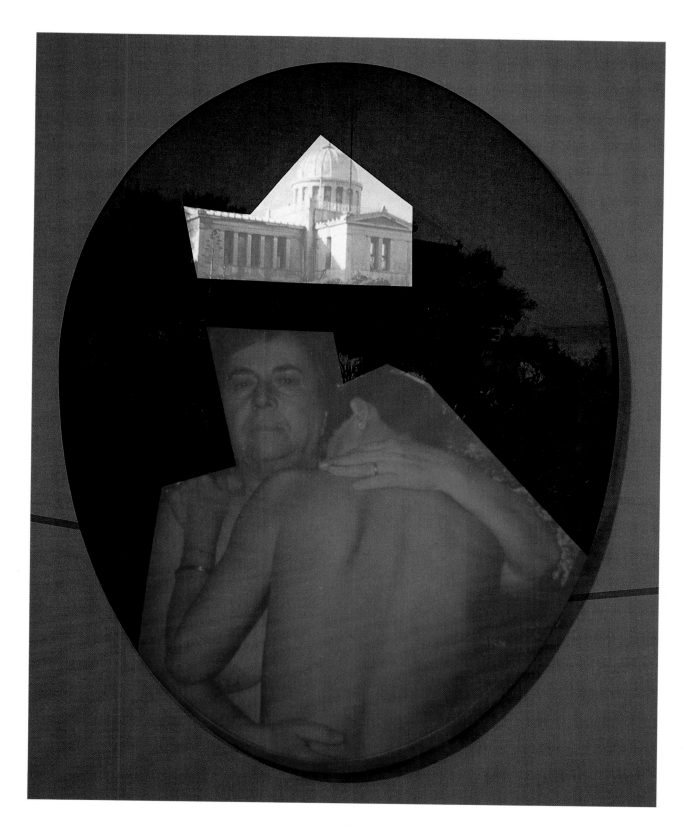

I : West, Asteroskopeion

Oil on linen, plywood, slide projection

160 × 122 × 7 cm

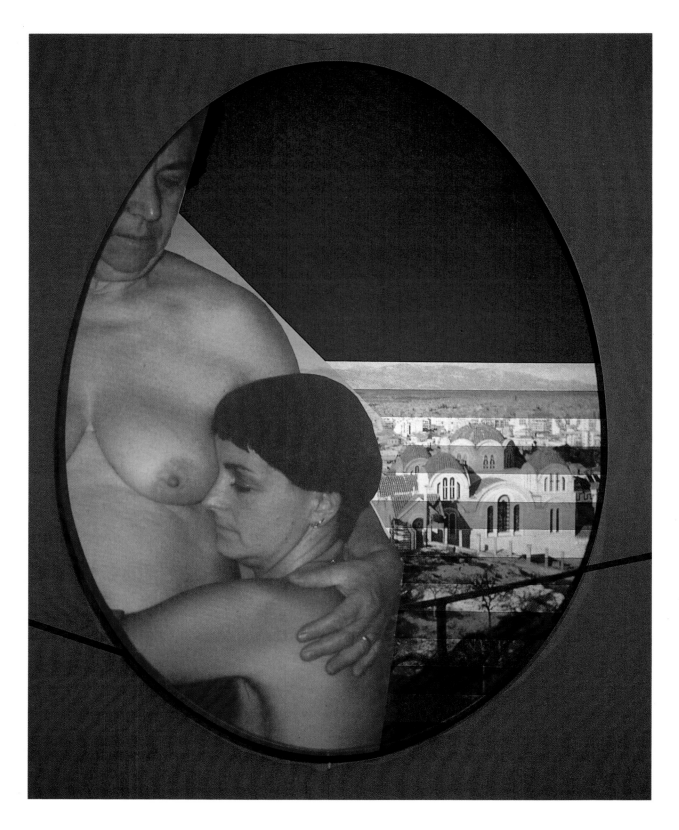

II : North, Agia Marina

Oil on linen, plywood, slide projection

160 × 122 × 7 cm

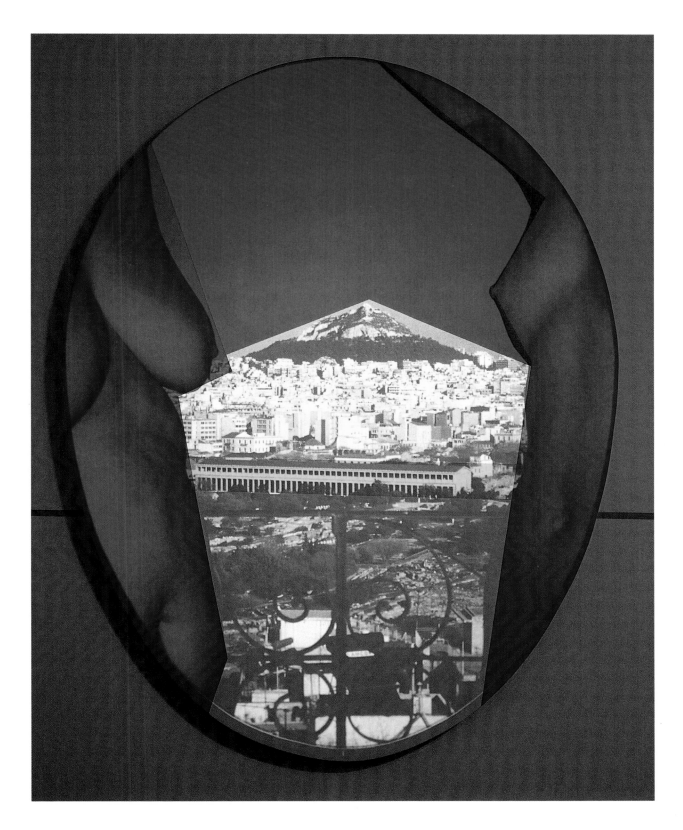

III : North East, Agora

Oil on linen, plywood, slide projection

160 × 122 × 7 cm

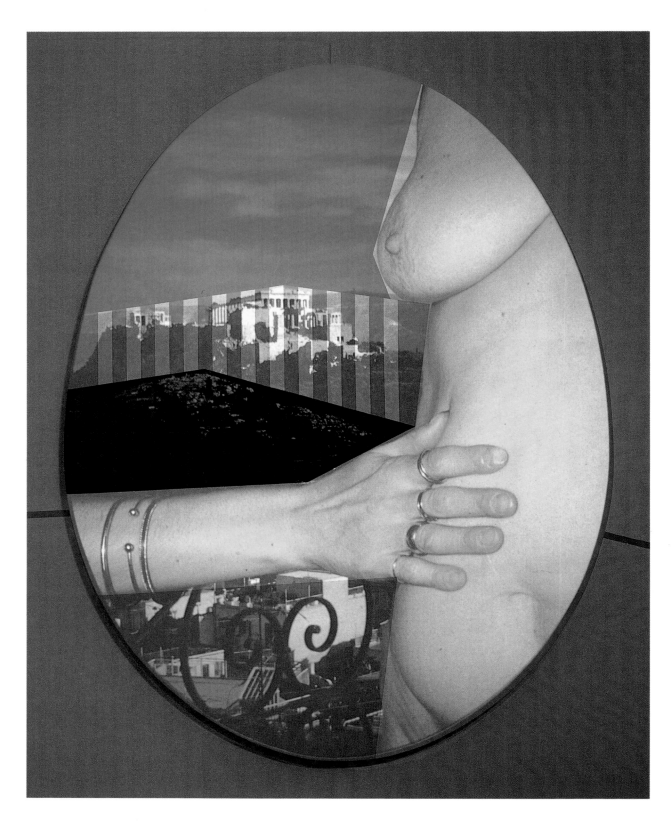

IV : East, Acropolis

Oil on linen, plywood, slide projection

160 × 122 × 7 cm

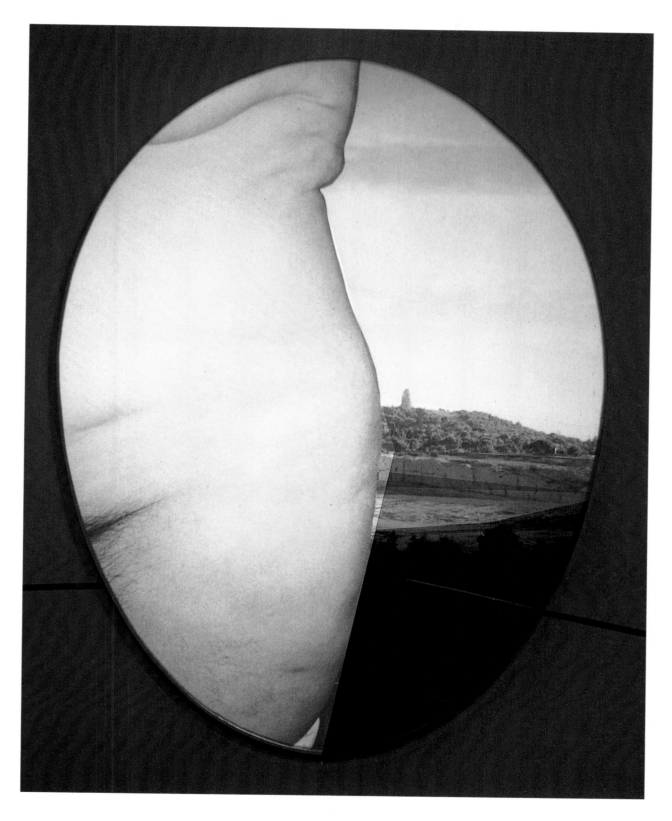

V : South South East, Pnyx

Oil on linen, plywood, slide projection

160 × 122 × 7 cm

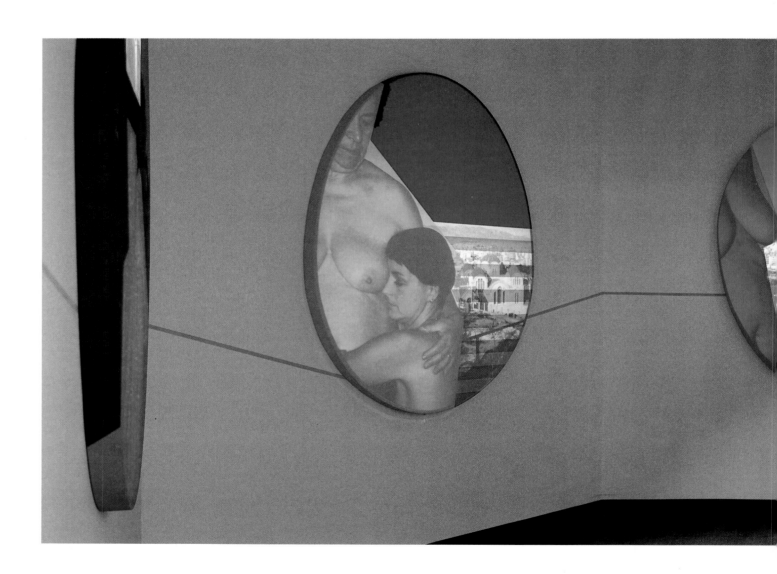

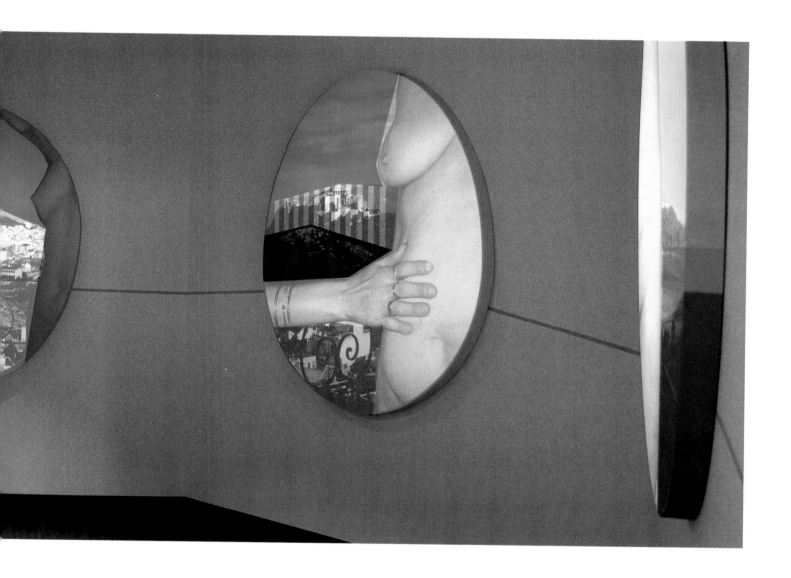

Lofos Nymphon

Installation with slide projection

Photographers' Gallery, London

Three Houses : A Modern Moral Subject

In the contemporary mind, home has become synonymous with property. No longer a site, a hearth, it equals value – accumulation, assets.

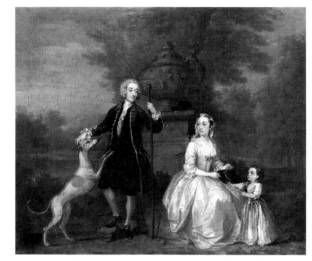

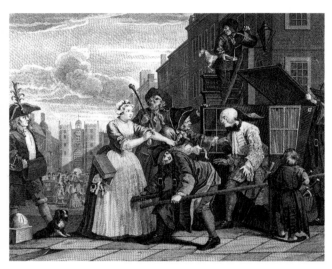

. . . A national obsession, but one that can be detected in the emergence of the first indigenous school of painting – the politely English *conversation piece*. Nearly three hundred years of restrained showing off, in which the comfortable are depicted at ease in their small corner of the world, solidly purveying their possessions in an atmosphere of peaceful continuity. Painted with precision, to seek verisimilitude in all details, these assertions of the plain if leisurely truth endorse the genealogy of privilege.

Only Hogarth came to parody the conventions of these diminutive middle-class pastorals, creating comic moralities to document the downwardly mobile unfortunates of his time – the country girls fallen to harlots, merchant sons to rakes. Bleak moralities as '*anti-conversations*' testify to the inevitability of collapse, wrought not by human foibles alone, but the overbearing mechanisms that define an individual and his place in the world.

As visions of commonplace reality, peopled by specific individuals, they proffer two extremes. Yet crucial to both is the mesh of social relations and whether it is reinforced or rent, in narratives of those who have and hold . . . or had and lost. For those *always* on the outside, beyond the happy landscape of ownership, what portraiture frames their reality? Vulnerable to the swell of housing values, the threat of dispossession still dominates the lives of the urban and rural poor.

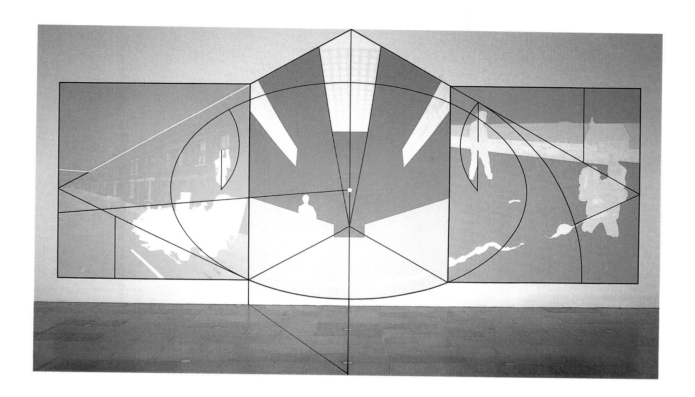

Helen Chadwick

I have lived and worked in this house for over ten years now.
It is the heartland of my life.
My studio is downstairs and although I live above, the
complete house is geared to the production of art.
Around me, many of my neighbours are artists.
In all, twenty-five houses in Beck Road
form a creative nucleus in the East End of London,
a community of 'industrial dwellings' where
home and workplace are joined.
With the escalation of property values in this area,
as licencees we have no security of tenure,
and the threat of
dispossession grows increasingly likely.
The thought of losing our homes is all-pervasive
and underscores our daily lives.
It is frightening to contemplate.

John Chadwick

We live and work on the South Downs.
I am a contracting shepherd.
My wife Jo and daughter Emily care for our own flock.
I have trained my dogs and work Roy, Kelly and Moss daily
to shepherd 3,000 ewes.
Our home is a tied cottage on a windswept hill which is
provided as a condition of employment. This is by annual
contract, reviewed every August – the only quiet time in the
shepherding year.
As local cottage prices have been forced up by commuters to
unrealistic levels, it makes it impossible for us and the
majority of people who work the land to buy their own house.
We are left with the insecurity that if the contract is not
renewed, we have to move immediately and find another job
with a tied cottage.
And so the situation repeats itself.

Three Houses : A Modern Moral Subject

Emulsion paint, tape, slide projection 305 × 274 × 640 cm

Installation without projections, Hayward Gallery, London, 1987

Overleaf, Installation with slide projection and self-portrait

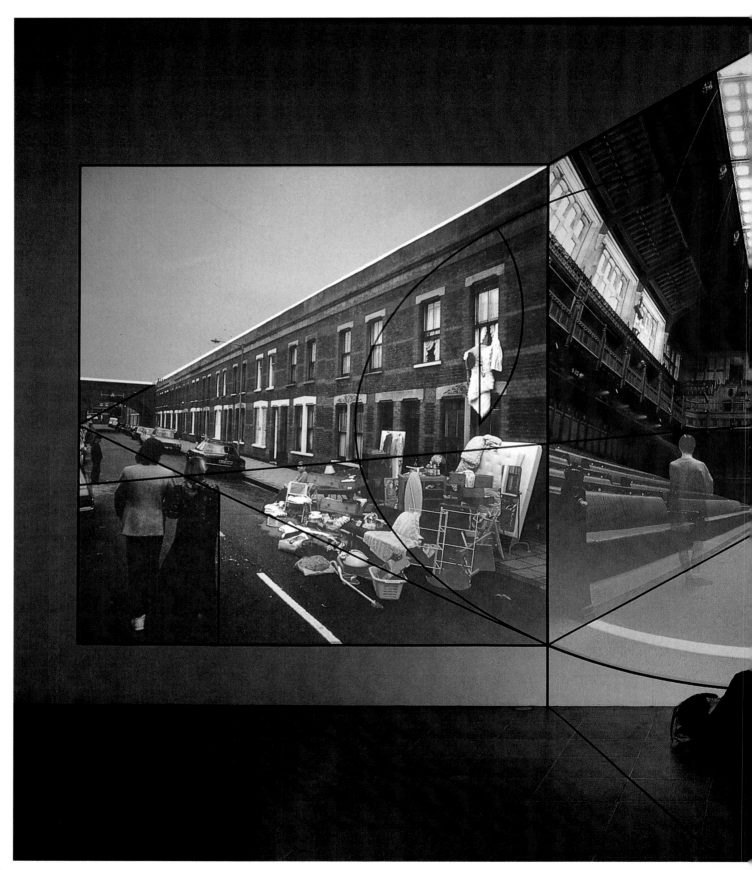

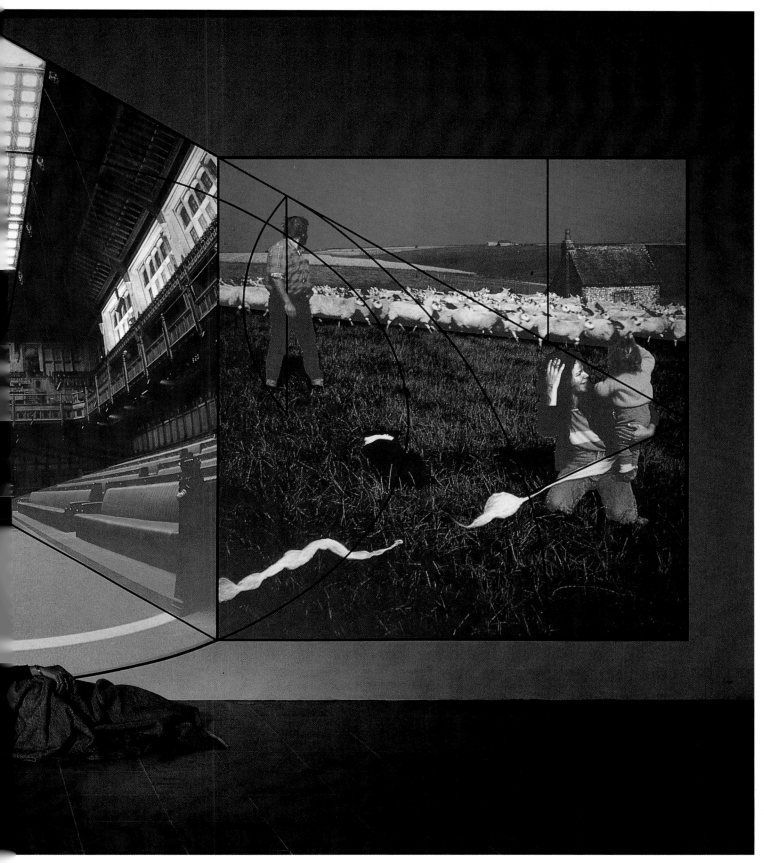

Blood Hyphen

An installation at Clerkenwell and Islington Medical Mission

And a woman having an issue of blood twelve years, which had spent all her living upon physicians, neither could be healed of any, Came behind *Him*, and touched the border of his garment: and immediately her issue of blood staunched.

The Gospel According to Saint Luke, Chapter VIII, 43–44

Linking beginning and end, the knife's cut to the gash of the lance, we trace a passage on the body of Christ from man to God . . . Christ's redemptive Passion, which culminates on the cross in the blood of the sacred heart, begins in the blood of the penis . . . The coupling of Christ's last and first wounds becomes topical in fifteenth and sixteenth-century Passion pictures that guide the trickle of gore from the breast back to the groin: a *blood hyphen* between commencement and consummation.

Leo Steinberg The Sexuality of Christ in Renaissance Art and in Modern Oblivion, *October No. 25, MIT Press, 1983*

I wish to call attention to artistic depictions that suggest that Christ's flesh was sometimes seen as female, as lactating and giving birth . . . Over and over again in the fourteenth and fifteenth centuries we find representations of Christ as the one who feeds and bleeds. Squirting blood from wounds often placed high in the side, Christ fills cups for his followers just as Mary feeds her baby . . . blood is what is emphasized – blood as covenant, in part, but primarily blood as suffering . . . Thus blood is redemptive because Christ's pain gives salvific significance to what we all share with him; and what we share is not a penis. It is not even sexuality. It is the fact that we can be hurt. We suffer.

Caroline Walker Bynum The Body of Christ in the Later Middle Ages: A Reply to Leo Steinberg,
Renaissance Quarterly, Vol XXXIX No. 3, 1986

By pressing the control pedal, the doctor can shoot the laser either as a short burst or a continuous beam. The direction of the beam is along an ordinary visible light beam – often red or purple – which shows up on the cervix where the laser is targeted. When the beam hits the cervix it completely vaporizes a tiny area . . .

Graham H. Barker FRCS, MRCOG Your Smear Test, *Adamson Books, 1987*

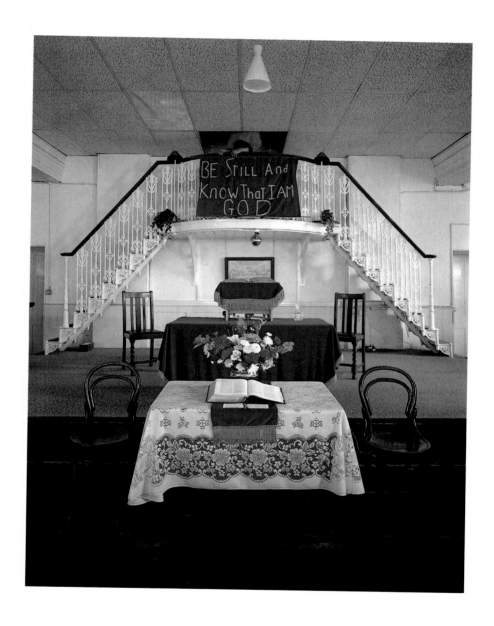

Chapel Interior

Clerkenwell & Islington Medical Mission, London

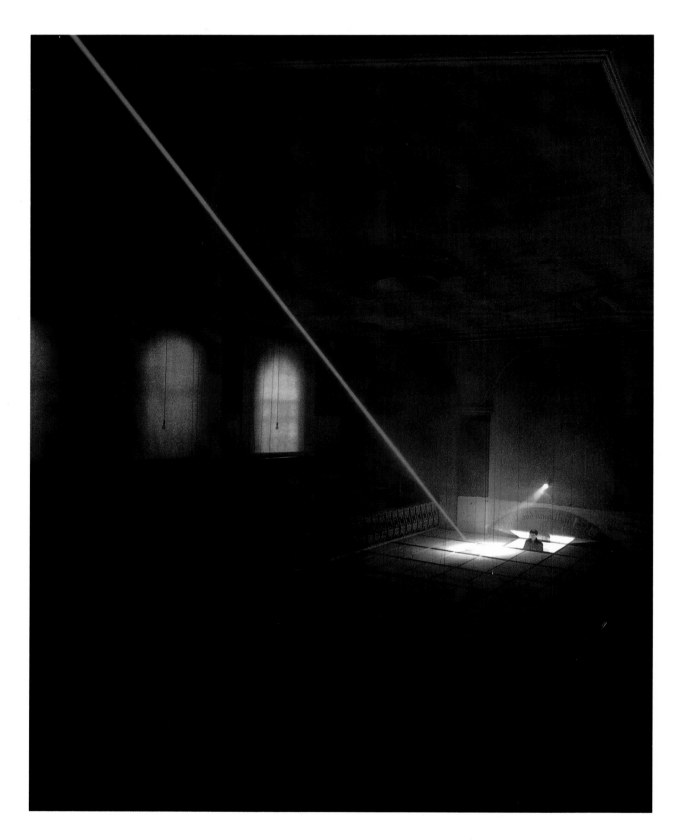

Blood Hyphen

Helium neon laser and assorted media

Installation in chapel vault, Clerkenwell & Islington Medical Mission

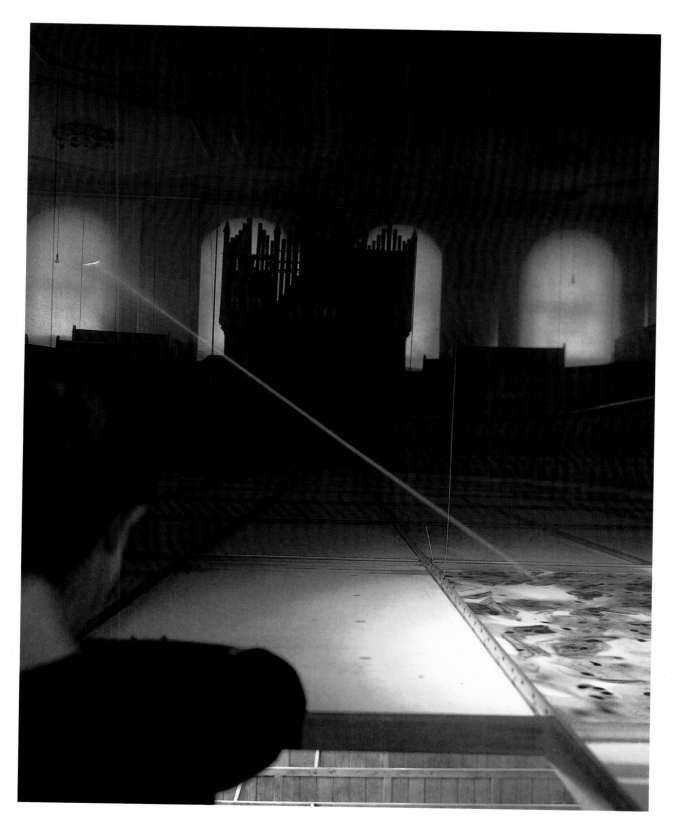

Blood Hyphen

Helium neon laser and assorted media

Installation in chapel vault, Clerkenwell & Islington Medical Mission

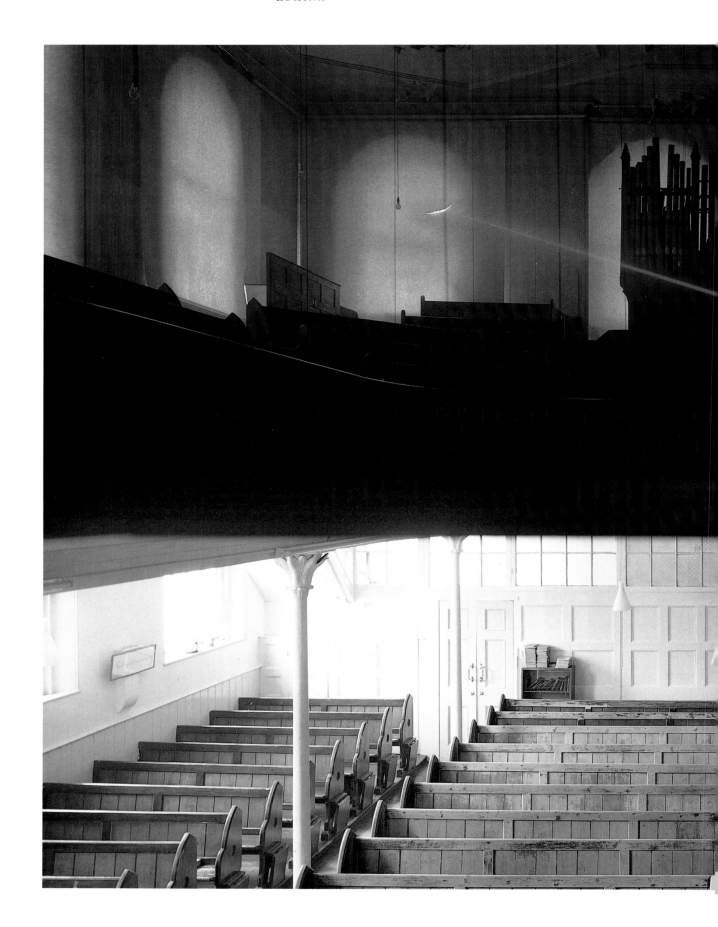

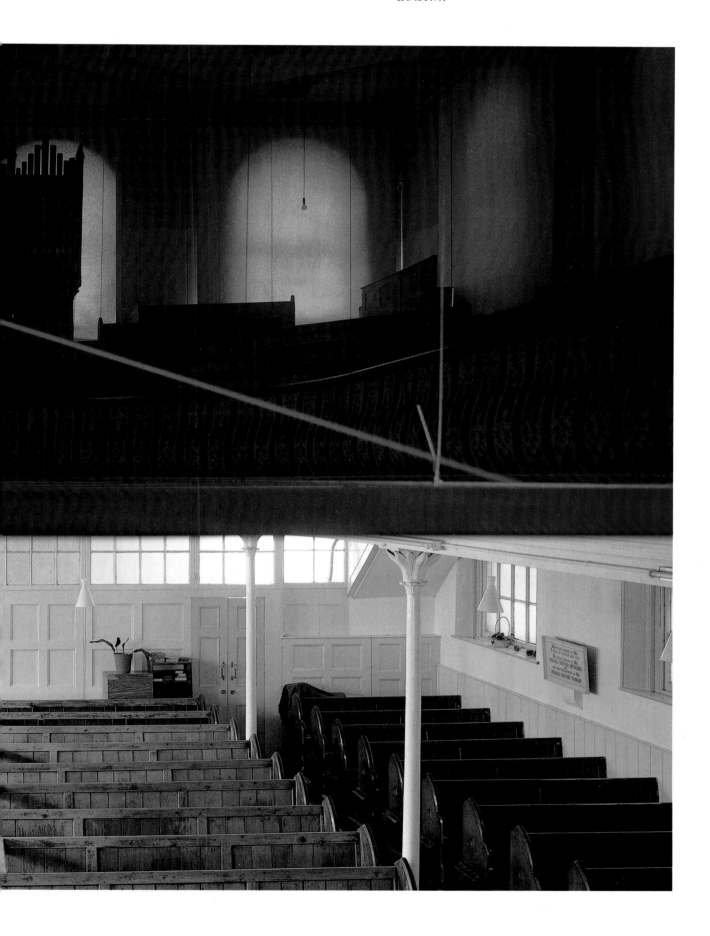

VIRAL LANDSCAPES

The last vestige of autonomy is the self-sufficiency of the cell, separated from all around by that first boundary, the protoplasmic envelope. It is the original frame. But it will yield to the impetus of a virus and surrender its sovereignty. In return a process begins. On the threshold of living, the virus hijacks the replication material of the cell to effect its continued proliferation. Essentially it is no more than chemical information, lifeless outside a biological system; a 'dissident' cultivating the possibility of change, if prejudiciously for its own ends.

Within a larger organism, the spectacle of violation of self, the destruction of one's separate integrity, might not altogether collapse into scenes of destruction. On the contrary, the self-referential narrative could part to reveal a radical openness. Willingly relinquished, the 'loss of cultural and personal co-ordinates'[1] could be a most productive moment, permitting the locus of unstable, permeable identities. The derelict corpse of the body-as-representation would disappear, slipping not into an ephemerality of medium but synchronous being. Only a ceaseless place, without limits, could host such fluctuations, restless subjectivities of unbridled yielding and return.

*1.
Margaret Soltan,
Night Errantry in New
Formations No. 5 Summer 1988*

At its most intimate, the abolition of frontiers renders my body up as cells and tissue, 'vulnerable to manifold incursions'.[2] Released from the bonds of form and gender, flesh is volatile and free to wander in an aetiology of complete abandon. This errantry cannot be errant, a pathological condition in a moralising space, for here in a scenario of mutual being the ideals of purity, and thus contagion, no longer apply. Previously, as punishment for vagrancy, the inevitable final closure would be death, but disintegration has already occurred. The living integrates with other in an infinite continuity of matter, and welcomes difference not as damage but potential. The story of susceptibility is reinscribed, affirmed in new dynamic rhythms as a counter-offensive to the terminal association of sexuality and disease. Spliced together by data processing, these are not ruined catastrophic surfaces but territories of a prolific encounter, the exchange of living and informational systems at the shoreline of culture.

*2.
ibid. I am indebted to the
author's fine essay in the
formulation of this commentary.*

The digitised image is infinitely available for modification, each latent pixel subject to change. Such access heralds a genetic revolution where life forms are prone to transformation in a mechanically reproduced reality. This stimulus to new solidarities could be emancipatory, an ecology where everything is connected and rigid boundaries cease to be. But viral aesthetics are contingent on risk. The shock of change asserts the need for immunologies, a vital relation of incompatible elements co-existing in gentle friction. This is the between *of nature – patterns of desire in symbiosis.*

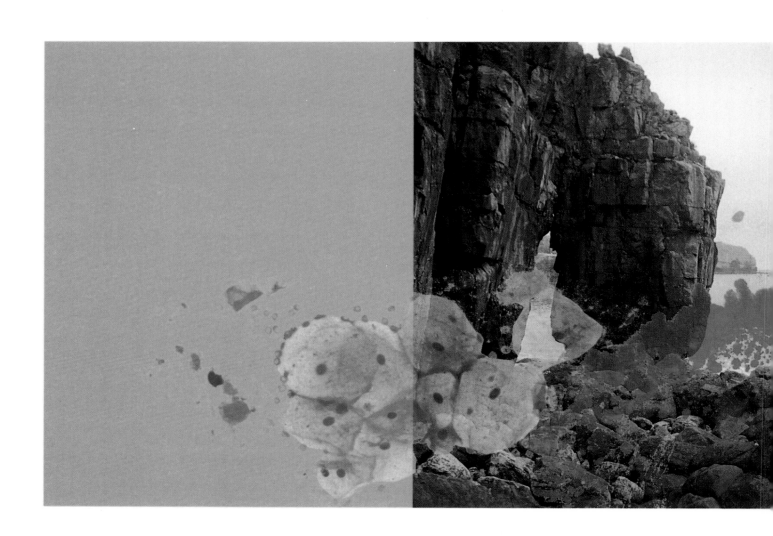

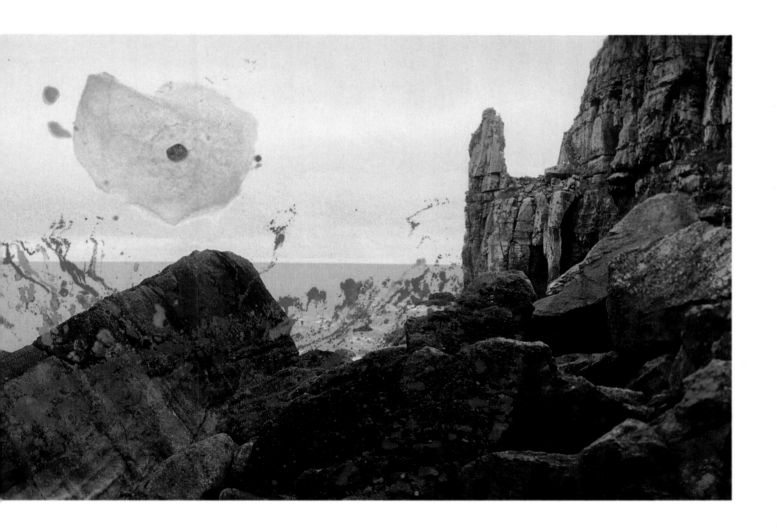

No. 1

Colour photographic print from cromalin proof

120 × 300 cm

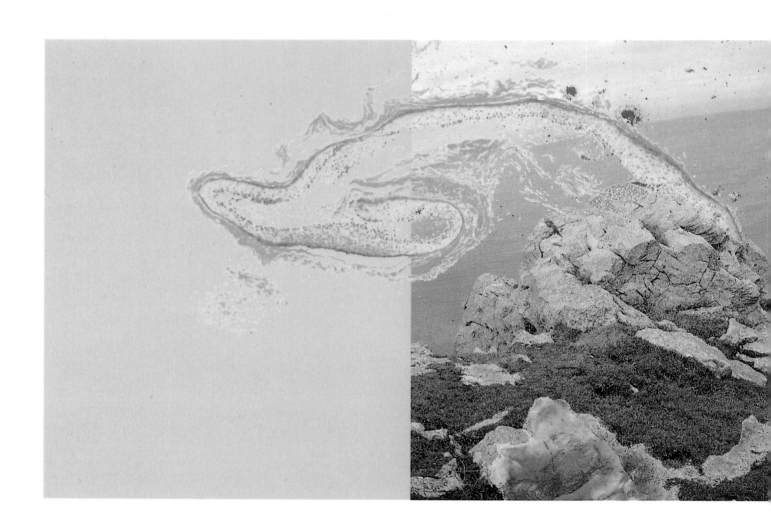

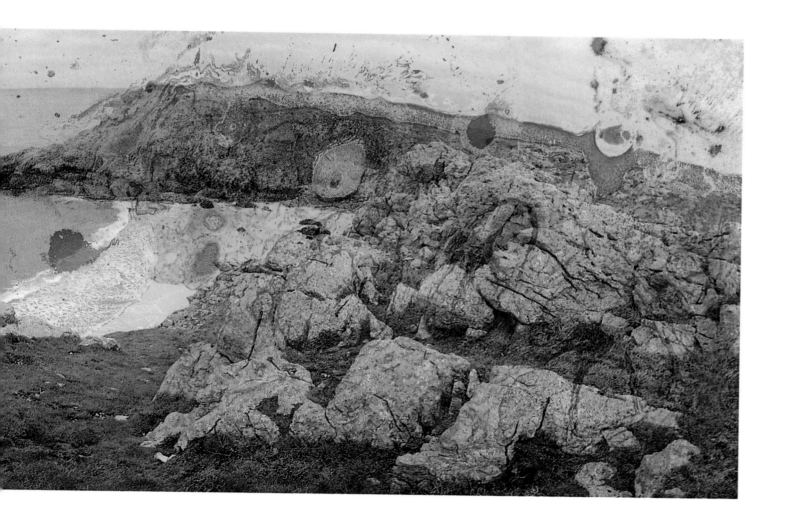

No. 2

Colour photographic print from cromalin proof

120 × 300 cm

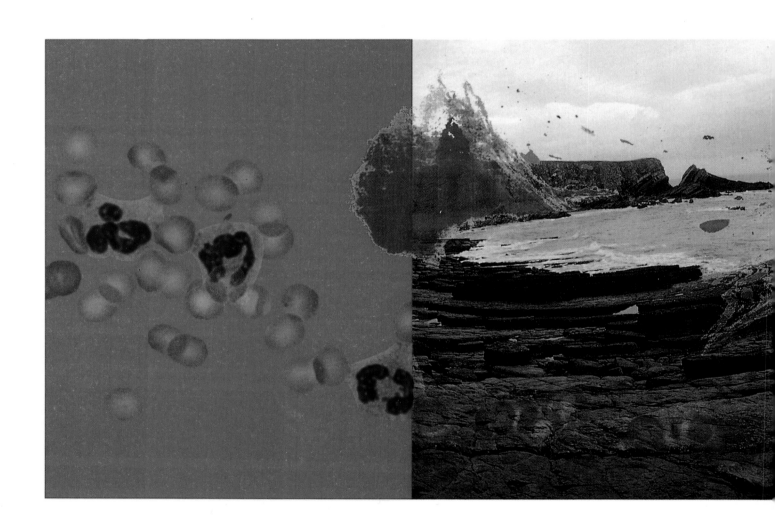

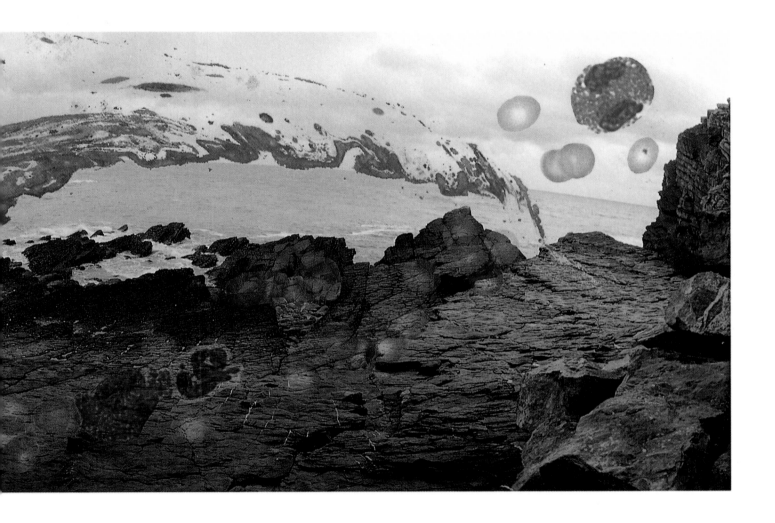

No. 3

Colour photographic print from cromalin proof

120 × 300 cm

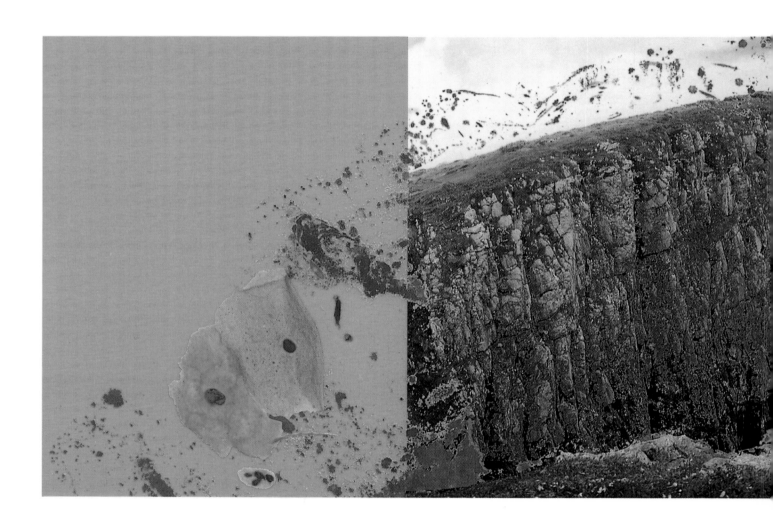

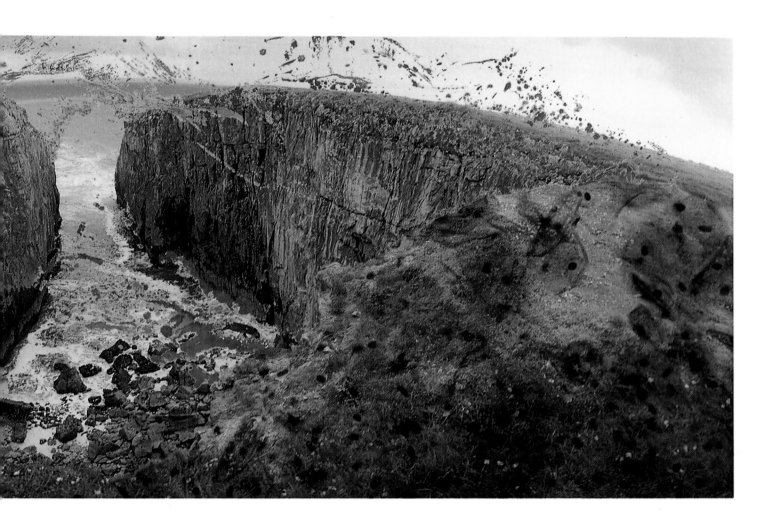

No. 4

Colour photographic print from cromalin proof

120 × 300 cm

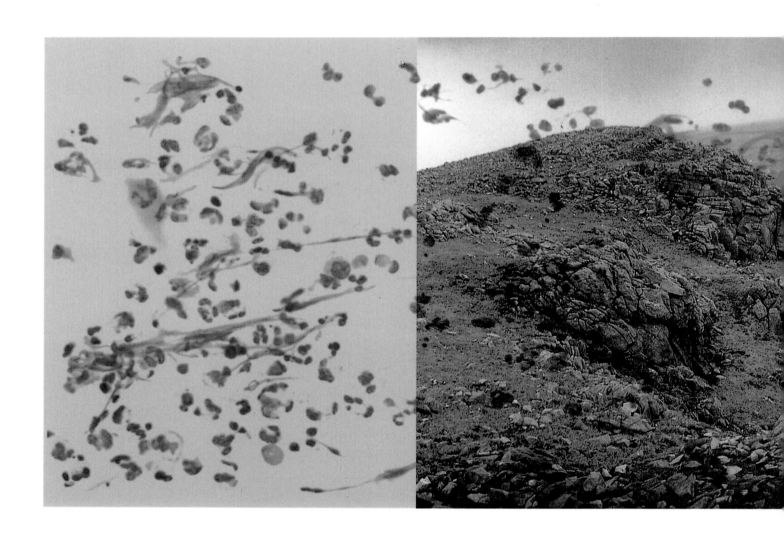

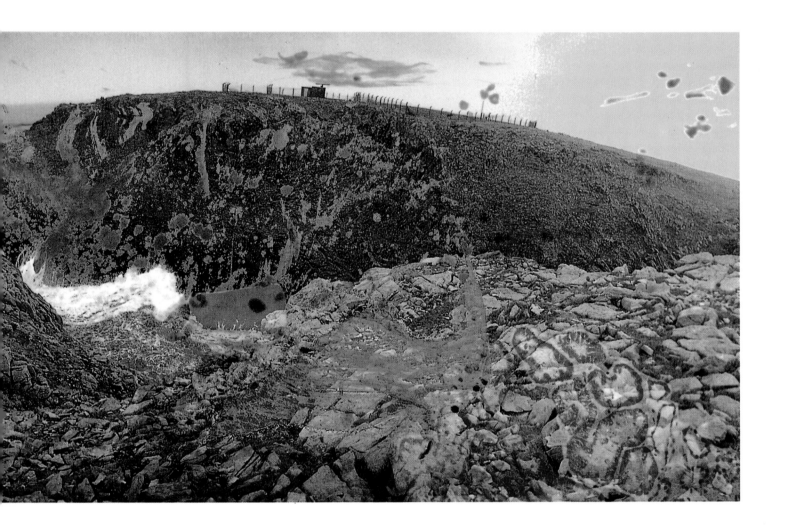

No. 5

Colour photographic print from cromalin proof

120 × 300 cm

Soliloquy to Flesh

My apparatus is a body × *sensory systems with which to correlate experience. Not exactly solid and real, I am none the less conscious, via physicality, of duration, of passing through. The sense of motion is emphatic, positing flesh-hood not as matter or image, but as process, a sequence of quantities of action. Like a bout of the hiccups, interactions keep making me happen, piecemeal. As links in a chain of reflex, I cannot be fixed in absolute terms, I can only present myself as variable, as event within the dynamic of place. What-is is what happens, made intelligible by charting the relations of perception to the physical.*

On impulse, I plan an incidence of self, in other words, a building site to develop in. As I proceed, things appear to change. The site curves around my presence whilst I in turn mould the geography of space. In mutual circumnavigation, the terrain waxes open, and following the path of least resistance, performs new convolutions. I mirror these curvatures. The architecture grows corporeal and I am enfleshed. In stories of origin and memory, cycles of transformation and decay, I narrate myself as envelopes of feeling quantised into flesh. There at the heart of these inscapes are enucleate abstracts eluding definition, stubbornly refusing to cohere.

Photography is my skin. As membrane separating this from that, it fixes the point between, establishing my limit, the envelope in which I am. My skin is image, surface, medium of recognition. Existing out there, the photograph appears to duplicate the world, disclosing me within its virtual space. But its range is elsewhere. Beyond the likeness I perceive another in-between, dilating in waves of harmony and dissonance, the tension of me for other. In parabolas, complementary functions of inside-outside, I plot the amplitude of difference, criss-crossing through this permeable screen. Pulled back and forth as message, the semblances are sinusoidal writing. Inside is outside is inside.

The eye reads these signals in the cool far retinal distance. Yet they occurred and are still in the knowing realm of touch. Intimate events of the moment of contact, happening once, are continually secured in place. This is not just light falling onto film, but tactile photography, the very sensitising of surface itself. The vital interface is here, where substance quickens to sensation in the eros of the moment. I graze the emulsion and by a process of interpenetration am dynamically returned: echoes of my falling onto picture are irradiated back as me again.

All these are propositions for being in the world, like physics. It seems I cannot distinguish anything as separate from myself so perhaps after all, I am the any-thing I observe. I use this eye/I reluctantly. Consciousness itself implicates me, moving out from what feels central to form relations with place, time, image, others, everything. There is nothing to explain, I have just to form the interruptions, this sequence of partial and approximate episodes which are self-consistent with my co-incidence. If I exist, it is as discontinuity, a transient state of inter-relations, pulse-like jumps in the illusion of things unfolding into fabricated space . . . pages turning in associated time.

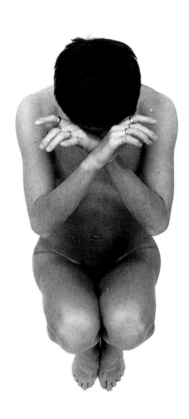

ENFLESHINGS

Helen Chadwick

Editor: Mark Holborn

Design: Kate Stephens

Typeset in Great Britain by Rowland Phototypesetting Limited

Printed and bound in Hong Kong by Mandarin Offset

Published in the United States in 1989 by

Aperture Foundation, Inc.

20 East 23 Street, New York, N.Y. 10010

Aperture Foundation, Inc. publishes a periodical, books, and
portfolios of fine photography to communicate with serious
photographers and creative people everywhere. A complete
catalog is available upon request.

Address: 20 East 23 Street, New York, N.Y.10010

Library of Congress Catalog Number 89–80750

ISBN 0-89381-394-X

Photographic credits:

pp. 12–13; 15–24; 41; 43 Philip Stanley. p. 73 Bruno Krupp

pp. 30–38; 45–71; 75–93 Edward Woodman

pp. 14 and 25 in collaboration with Mark Pilkington

p. 40 GDS computer plot with Philip Stanley, The Thomas Saunders Partnership

pp. 77–83 computer montage with London College of Printing & Crosfield Electronics

pp. 98–107 computer montage with Crosfield Electronics

Collections:

pp. 4, 30–31 and 52–53 The Board of Trustees of the Victoria & Albert Museum, London.

p. 21 Contemporary Art Society, London. p. 22 Arts Council of Great Britain.

p. 50 National Gallery, London. p. 54 Dolores Olmedo, Mexico City.

p. 60 Wellcome Institute Library, London. p. 72 Birmingham City Museum and Art Gallery.

p. 84 Courtesy of the Trustees of the British Museum. p. 84 Tate Gallery, London.

Acknowledgements:

The artist gratefully acknowledges the support of Ian Bourn;

Les Carr; Stan Cook; Mark Haworth-Booth and

Chris Titterington of the Victoria & Albert Museum; Gerard Wilson